Winslow HOMER

and the Sea

Carl Little

Pomegranate

SAN FRANCISCO

A CHAMELEON BOOK

Published by Pomegranate Communications, Inc.
Box 808022, Petaluma CA 94975
800 227 1428 707 782 9000
www.pomegranate.com

Pomegranate Europe Ltd.
Unit 1, Heathcote Business Centre, Hurlbutt Road
Warwick, Warwickshire CV34 6TD, UK
[+44] 0 1926 430111
sales@pomeurope.co.uk

Produced by Chameleon Books, Inc.
Chesterfield, Massachusetts

Library of Congress Cataloging-in-Publication Data

Little, Carl.
 Winslow Homer and the sea/Carl Little.—1st ed.
 p. cm.
 1. Homer, Winslow, 1836–1910—Criticism and interpretation. 2. Sea in art. 3. Coasts in art. I. title.
 ND237.H7L48 1995 95-31391
 759.5—dc20 CIP

Pomegranate Catalog No. A807

ISBN 978-0-87654-479-2

Designed by John Malmquist Design

Printed in Korea
18 17 16 15 14 13 12 11 10 14 13 12 11 10 9 8 7 6 5

First Edition

CONTENTS

ACKNOWLEDGMENTS

Since Winslow Homer's death in 1910, nearly every aspect of his work has been analyzed—the illustrations, the Civil War images, the watercolors, the Prout's Neck pictures. The present book is the first to focus on the full range of Homer's coastal subjects, his grand theme, if you will, which began with seashore vignettes drawn for the illustrated journals of the day and ended with the powerful Maine seascapes and luminous Caribbean watercolors of his maturity.

The selected bibliography that Philip C. Beam, Herbert Johnson Professor of Art and Archaeology, emeritus, Bowdoin College, appended to his marvelous book *Winslow Homer at Prout's Neck* (1966) testifies to the wealth of writings on this artist: it runs eight pages, single-spaced. Since Beam published his book, the Homer literature has more than doubled, and the list of his champions has grown exponentially. Joining the likes of William Howe Downes, Kenyon Cox, Lloyd Goodrich, Mahonri Sharp Young, James Flexner, and Albert Ten Eyck Gardner are such eminent art historians as Donelson Hoopes, John Wilmerding, Gordon Hendricks, Natalie Spassky, Nicolai Cikovsky Jr., Helen Cooper, David Tatham, Alexandra Murphy, and Bruce Robertson—to name but a handful. Each of them has added to our understanding of Homer's life and art; to all of them the author expresses his indebtedness.

Grateful acknowledgment is given to the following individuals who provided invaluable help in the course of the writing of this book: Jessica Nicoll, Curator of American Art, and Michelle Butterfield, Registrar, Portland Museum of Art; Kathleen V. Kelley, Registrar, Bowdoin College Museum of Art; Dianne M. Gutscher, Curator of Special Collections, Hawthorne-Longfellow Library, Bowdoin College; Muriel Sanford and Betsy Paradis, Special Collections Librarians, University of Maine at Orono; the librarians of Mount Desert Island; and the author's brother David Little. The author is also grateful to Philip Beam, Nicholas Snow, and Kate Barnes for permission to reprint text in the book. Thanks again to Arnold Skolnick, bookmeister and friend.

The true key to this writer's enterprise is the encouragement of his family—Peggy, Emily, and James. So it is to that patient threesome that this "Homer-work" is dedicated.

—Carl Little, Mount Desert, Maine, July 1995

PREAMBLE: THOUGHTS ON A NAME

Homer: simplest and humblest of names that, paradoxically, conjures up the sweep of civilization, the *Iliad* and the *Odyssey*, the great blind singer/poet, Godlike, giving shape to the world and its inhabitants. In line with this train of thought, art historian Mahonri Sharp Young once wrote that Winslow's last name "was just right for a man who loved the sea."[1]

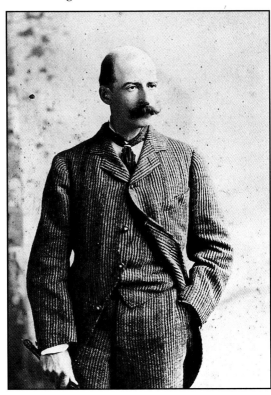

Winslow Homer: perfect pairing, rolling assonance, strong yet sibilant configuration, suggestive of an afternoon breeze tugging a sailboat toward port—to home. It's the kind of name that turns up in poet Robert Lowell's meditations on his New England kin; an old-fashioned name to us today, one you'd come across in a cemetery way in the woods or in a seaside town; a name you'd imagine might be preceded by the title "Captain": Captain Winslow Homer, master of the ship—no, master of his art.

Winslow Homer
Photograph by Napoleon Sarony
Courtesy Bowdoin College Museum of Art,
Brunswick, Maine

WINSLOW HOMER'S COASTS

Like the sea itself, the shore fascinates us who return to it, the place of our dim ancestral beginnings. In the recurrent rhythms of tides and surf and in the varied life of the tide lines there is the obvious attraction of movement and change and beauty. There is also, I am convinced, a deeper fascination born of inner meanings and significance.
—Rachel Carson, *Edge of the Sea*, 1955

The world has many edges. There is the place where the desert meets the mountains, where the meadow becomes the woods, where the rocks slip down beneath the sea. The elements often blend at these borders; sometimes mystery ensues, sometimes a confrontation takes place. More often a beauty is born of the commingling.

The edge of the sea, as Rachel Carson notes, is a natural zone that elicits deep "fascination" from those who study it. A kind of hypnosis takes place when one contemplates the ocean—I think of Virginia Woolf's mesmeric novel *The Waves* or of what Robert P. Tristram Coffin once wrote: "The tremendous whisper of the things the sea tries to tell to men runs through and through the hours like peace."

Of American artists, one perhaps above all others was captured by the spell of the coast: Winslow Homer (1836–1910). To some extent, Homer's life and art can be measured through his pictures of coastal subjects, from

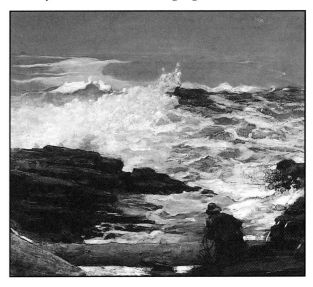

Driftwood, 1909
Oil on canvas, 24½ x 28¼ in.
Henry H. and Zoë Oliver Sherman Fund and other funds
Courtesy Museum of Fine Arts, Boston

the illustrations engraved from his drawings of beach scenes in Massachusetts, Rhode Island, and New Jersey early in his career, to an oil painting of a fisherman preparing to haul a piece of wood out of the surf at Prout's Neck, Maine—*Driftwood,* 1909—thought to be the artist's last canvas. In between, Homer made his way from one coast to another, from Gloucester to East Hampton to Atlantic City; to northern England; to Bermuda, Cuba, Florida, and the Bahamas, never straying far from the water. Even when he headed inland, on fishing—and painting—trips to the Adirondacks and Canada, Homer was drawn to watery expanses and the unruly ways of rushing rivers.

I think it was Coleridge who spoke of the inspiring wind as a key to the Romantic poets' enterprise. So Homer thrived by the seacoast where the wind makes its presence most known, be it the blast of a northeaster or the beneficent airs of the trade winds. He knew firsthand the fury of the hurricane, but also the quiet after the storm, when the rising sun lights up one last fling of surf or reveals a sailor prone on the sand by his broken boat. On occasion he went out on the water, adding to his knowledge of the fisherfolk whom he admired and paid tribute to in his paintings.

N. C. Wyeth remarks in one of his letters that Homer painted the sea "for the first time in history as it really looked"—a considerable claim, yet most art historians no doubt would agree. Homer devoted much of his life to a study of the sea, to walking the coastal reaches, most notably while in England and after he moved to Prout's Neck in 1884. Known to pause and gaze at the ocean in the course of his wanderings, he was just as well known to return to his studio for art materials, to capture his impressions on paper or canvas.

Homer was an outward-looking artist. He painted few self-portraits and never went in for society commissions. Literary-fantasy art—symbolism, mysticism, etc.—was also of little interest to him. "If a man wants to be an artist, he should never look at pictures," he is reported to have pronounced early in his career. Had he known where his steps would lead him, Homer might have added: "He should look at the coast."

THE YOUNG ARTIST: "WIN WANTED TO DRAW."

My northern pines are good enough for me,
But there's a town my memory uprears—
A town that always like a friend appears,
And always in the sunrise by the sea.
—Edward Arlington Robinson, "Boston"

Born in Boston on February 24, 1836, Homer descended from men connected to the sea, mainly merchants. His father, Charles Savage Homer, was an ex-forty-niner, a somewhat shady entrepreneur—"a promoter," as Winslow's nephew Charles L. Homer described him, who "probably moved to keep ahead of the sheriff."

Homer's artistic bent has often been ascribed to his mother, Henrietta Maria Benson, an amateur—yet accomplished—watercolorist who encouraged her son to pursue art. In his biography of the artist, Lloyd Goodrich quotes one of Homer's cousins giving unalloyed credit to Mrs. Homer for her son's artistic development, even going so far as to imply prenatal influence: "I went to see her *just* before Winslow was born," the cousin recounted, "and she had on a big pinafore and was standing before a large easel, painting."

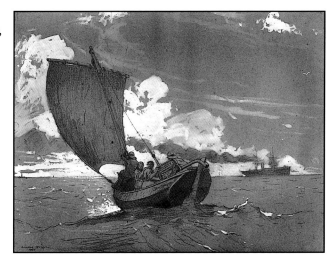

Fishing Off Scarboro, 1882
Watercolor, 17½ x 23½ in.
The Art Institute of Chicago
Mr. and Mrs. Martin A. Ryerson Collection, 1933.1240
Photograph © 1995 The Art Institute of Chicago
All rights reserved.

While still young, Homer moved with his family to nearby Cambridge. As Charles S. Homer, Jr., the artist's older brother, recalled, Winslow avoided higher education in favor of other pursuits. "I was the only one that wiggled through Harvard College," Charles said, but "Win wanted to draw."

Homer's family, which included his younger brother, Arthur, served as a lifelong base of support for the artist, extending to patronage: it was Charles who bought his brother's first two oils, unbeknownst to the artist. As Goodrich relates, "Several years later when Winslow visited him and saw one of the pictures, he swore roundly and refused to speak to his brother for weeks."

At just shy of twenty years of age, Homer was apprenticed to a lithography workshop. Working from photographs and from other artists' work, he drew images for sheet music covers. Grindstone, treadmill, slavery—that's how the artist and others have described his existence at this time, and yet the training stood Homer in good stead. Indeed, he came to define talent as "the capacity for doing continuous hard work in the right way" and was certified an academician by the National Academy of Design at the youthful age of thirty.

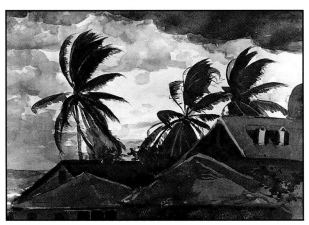

Hurricane, Bahamas, 1898/1899
Watercolor, 14½ x 21 in.
The Metropolitan Museum of Art, New York
Purchase, 1910, Amelia B. Lazarus Fund, 10.28.7

Upon completing his apprenticeship, Homer promptly quit. "From the time that I took my nose off that lithographic stone," he later said, "I have had not master; and never shall have any." He set about establishing himself as a free-lance illustrator, contributing to the journals of the day, most notably *Harper's Weekly*. In October 1859, he moved to New York City, which served as his base of operations until he took up residency at Prout's Neck on the coast of Maine in 1884.

[Homer's] early works had many curious parallels with that of the French impressionists, but they were not the result of influence, for impressionism had not yet been born in France. He was an independent American pioneer of impressionism.

—LLOYD GOODRICH,
American Watercolor and Winslow Homer, 1944

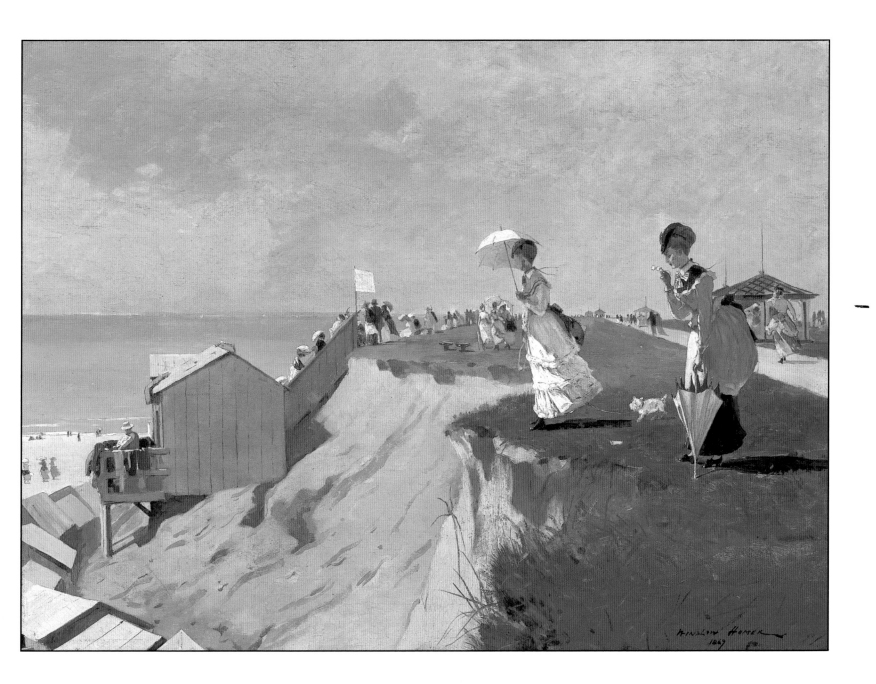

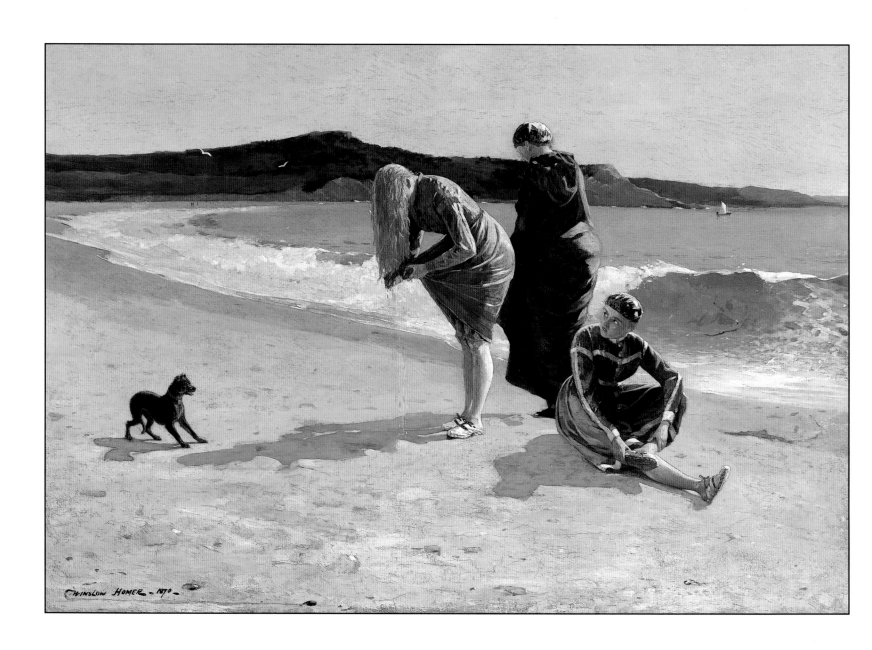

PLATE 2 *Eagle Head, Manchester,*
Massachusetts (High Tide), 1870
Oil on canvas, 26 x 38 in.
The Metropolitan Museum of Art,
New York
Gift of Mrs. William F. Milton, 1923

Once created, the wave or the arc of a wave begins
its journey through the sea. Countless vibrations
precede it, countless vibrations follow after. It
approaches the continent, swings into the coast
line, courses ashore, breaks, dissolves, is gone.
The innermost waters it last inhabited flow back
in marbly foam to become a body to another beat,
and to be again flung down. So it goes night and
day, and will go till the secret heart of earth
strikes out its last slow beat and the last wave
dissolves upon the last forsaken shore.

—HENRY BESTON,
The Outermost House, 1928

"THE ILLUSTRATOR'S EYE"

Realism, as painter Rockwell Kent once pointed out with an exclamation point, was Homer's *"job* in youth!" As he had little in the way of formal training,[2] it was, said Kent, the artist's "actual, stark, unadorned reporting" that was the foundation for his realist aesthetic.

Walter Pach once observed that the illustrator can be a "true artist" or a "mere commercialist." In studying the work of Homer, Pach noted, "we see that telling a story or representing a scene . . . has been the point of departure for much of the best art of all time." David Tatham takes this point a step further: "If [Homer] had not been a master of the art of illustration, he would have been a different painter from the one we know." In Tatham's opinion, "The illustrator's eye made the difference."

Homer's reportorial prowess was strengthened during the Civil War when he made several visits to the Union Camps on assignment for *Harper's Weekly;* he also covered Lincoln's inauguration in Washington, D.C. It was after the war that he began to train his eye on the coast. One of his first postwar illustrations for *Harper's Weekly,* titled *Our Watering-Places—The Empty Sleeve at Newport* (August 26, 1865), depicts a one-armed veteran being chauffeured in a buggy to the beach by a female companion. In many such pieces he did in that period, the seashore serves as a backdrop to social comment, to romantic dramas, or to domestic vignettes. In *The Bathers* (*Harper's Weekly,* August 2, 1873), two paper doll–stiff women in full-length bathing suits strike odd poses against a placid sea. Equally unreal are the figures

Our Watering Places—The Empty Sleeve at Newport
Wood engraving, *Harper's Weekly,* August 26, 1865
The Metropolitan Museum of Art, New York
Harris Brisbane Dick Fund, 36.13.11(1)

in *The Wreck of the "Atlantic"—Cast Up by the Sea* (*Harper's Weekly*, April 26, 1873), yet here the rugged coast that serves as the setting begins to resemble what Homer would come to paint many years later.[3] Curious to note, these somewhat surreal scenes were the kind of nineteenth-century images that Max Ernst would appropriate—cut up— to create his extraordinary collages of the 1920s and 1930s.

The Universal Exposition of 1867, which included two Homer canvases, drew the thirty-year-old artist to France, where he spent nearly a year. He stayed in Montmartre; on the evidence of the Paris scenes he contributed to *Harper's*, Homer visited the Louvre, the Casino de Paris, and the Bal Mabille, one of Paris's most popular dance halls. Art historians have written extensively about the art Homer may have seen while in France—Japanese prints, paintings by Manet, Courbet, and so on. Considering the stylistic shifts that occur in his work after that trip, it is certain the artist saw *something,* but until we uncover a Paris diary, we'll never know exactly what. Safer, it is, to highlight a parallel in aesthetics than to claim a direct indebtedness. Thus, critic Robert Hughes notes how Courbet's "rolling waves, marbled with foam as solidly as a steak is with fat, reappear on the other side of the Atlantic in Winslow Homer's sea pieces at Prout's Neck in Maine."[4]

In the late 1860s and early 1870s, Homer spent time in Long Branch, a seaside resort situated on the northern coast of New Jersey. The beach and its bluffs were the subject of a number of illustrations for *Harper's* and for some of Homer's earliest marine paintings. *Long Branch, New Jersey*, 1869 (Plate 1), considered his first seascape in oil, is rendered in

The Bathers
Charcoal and white chalk
The Metropolitan Museum of Art, New York
Rogers Fund, 20.113

PLATE 3 *On the Beach,* c. 1870
Oil on canvas, 14 x 20 in.
Canajoharie Library and
Art Gallery
Canajoharie, New York

Mr. Homer has the great merit . . . that he naturally sees everything at one with its envelope of light and air.

—HENRY JAMES,
The Galaxy, 1875

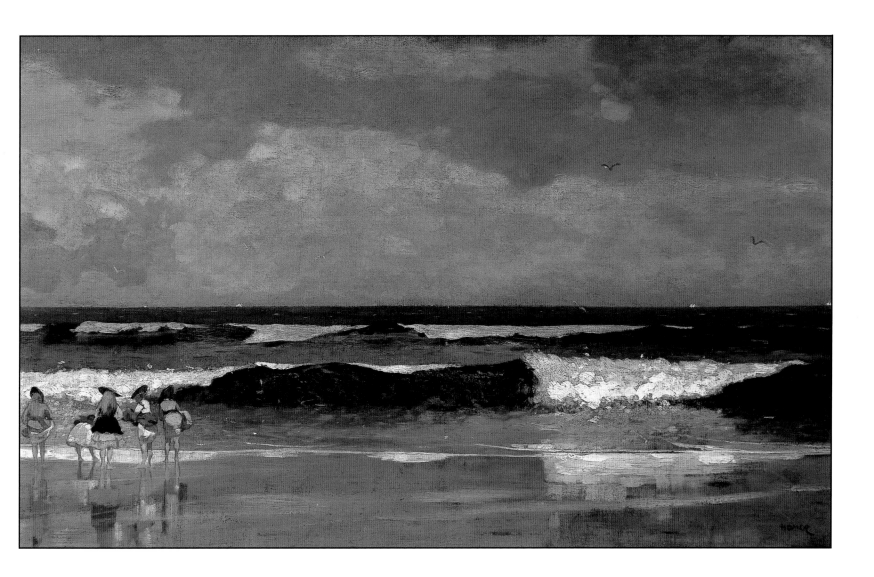

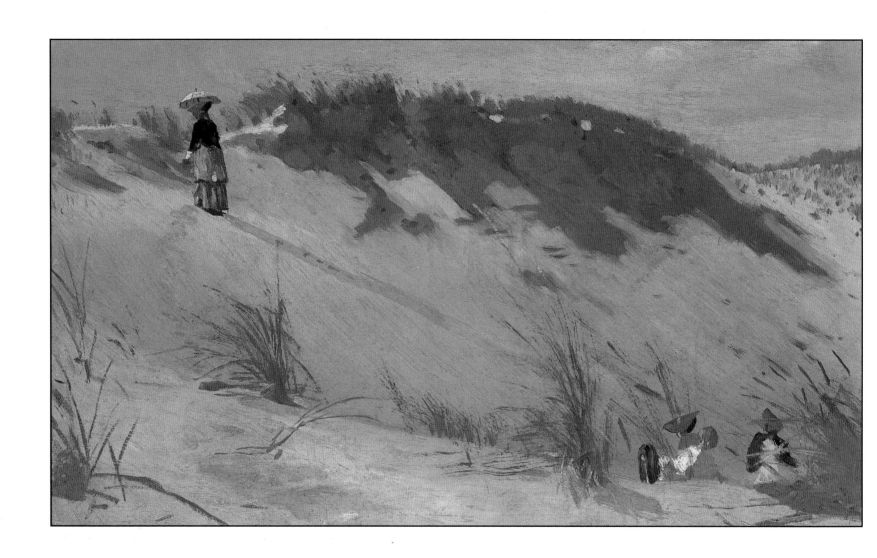

PLATE 4 *The Sand Dune*, c. 1872
Oil on canvas, 13 x 21½ in.
Adelson Gallery, Inc., New York

Sometimes it is asked, "What might not Winslow Homer have done if he had had a thorough art education at the beginning of his career?" I fancy that those who ask this question do not know what a great school Nature is when the pupil is a persistent searcher for truth and has the strength of purpose that has enabled Mr. Homer to find adequate forms of expression in his own way.

—WILLIAM A. COFFIN,
Century Magazine, September 1899

what art historian Gail Scott calls the "American proto-impressionist idiom" that characterizes the artist's canvases of this period.

Homer also painted views on the Massachusetts coast, Manchester and Marshfield being two spots where he set up easel. In *High Tide* (also called *Eagle Head, Manchester, Massachusetts*), 1870 (Plate 2), three women have just finished bathing in the sea; a small dog, tense with anticipation, awaits their departure. Behind the figures the coastline makes a wide curve toward low-lying headlands; and there is a breaking wave, one of Homer's first attempts at the motif, which attests to a hand already accomplished at rendering the dynamics of the sea. While Philip Beam rightly calls Homer's views of the ocean from this period "tame as compared to later conceptions," the artist made steady gains in his abilities to render the coast. Summers in Gloucester would further acquaint his brush and palette with the subject of the shore.

The Wreck of the "Atlantic"—Cast Up by the Sea
Engraving, *Harper's Weekly*, August 26, 1873
The Metropolitan Museum of Art, New York
Harris Brisbane Dick Fund, 29.88.9(1)

PLATE 5 *The Berry Pickers*, 1873
 Watercolor and gouache
 over graphite, 9³⁄₈ x 13⁵⁄₈ in.
 Collection of Mr. and Mrs. Paul
 Mellon, Upperville, Virginia

*An admirable instance of expressiveness of
Homer's composition . . . is the little watercolor
of Berry Pickers of 1873. At first sight it is a
simple transcript from nature, with little style
in either the drawing or the color, yet it is full of
a charm difficult to account for. And then one
notices that the lines of all the subordinate figures
lead straight to the head of the taller girl,
standing alone on the left, and that she has a
blowing ribbon on her hat. The line of that ribbon
takes possession of the eye, which is carried by it,
and by the clouds in the sky, straight across the
picture to the other end where, so small as to be
otherwise unnoticeable, a singing bird sits upon
the branch of a bare shrub. By that subtle bit of
arrangement the air has been filled not only
with sun and breeze but with music, and the
expression of the summer morning is complete.*

—KENYON COX,
Winslow Homer, 1914

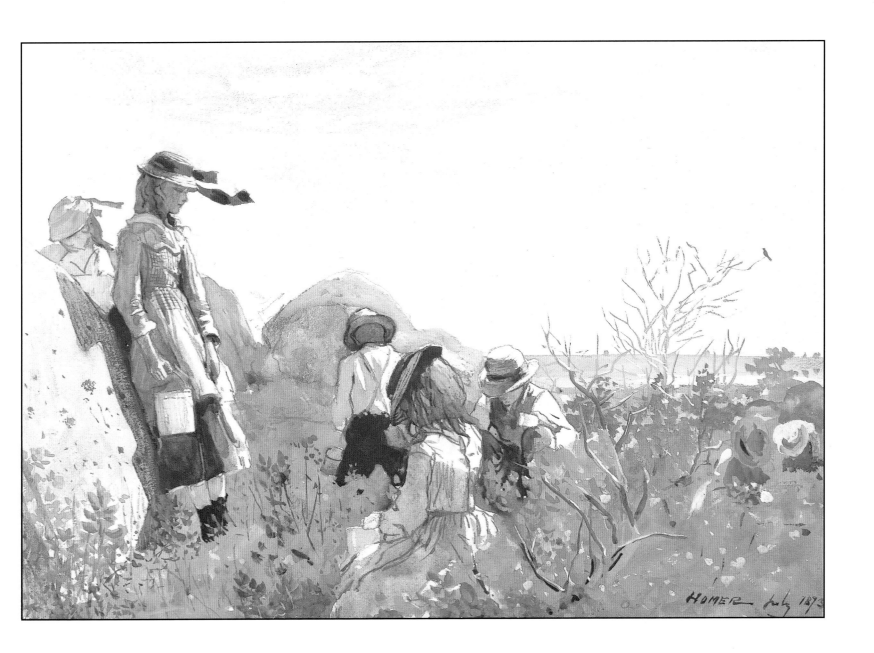

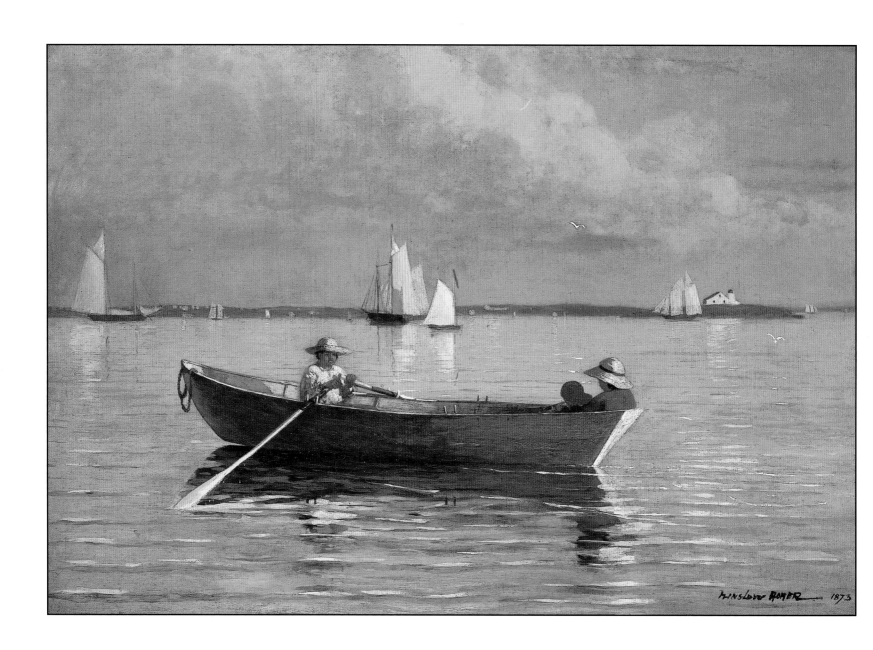

PLATE 6 *Gloucester Harbor,* 1873
Oil on canvas, 15$^1/_2$ x 22$^3/_8$ in.
The Nelson-Atkins Museum
of Art, Kansas City, Missouri
Gift of the Enid and Crosby
Kemper Foundation

*So much is made of "schools"—as though the
term were of a definite, inclusive and exclusive
significance comparable to the label of a
geographical and governmental unit! "Winslow
Homer: American School": how could he have
been when there was then no American School?
He is related in spirit to that nineteenth-century
French revolutionary in realism, Gustave
Courbet. To Manet—sometimes, superficially.*

—Rockwell Kent

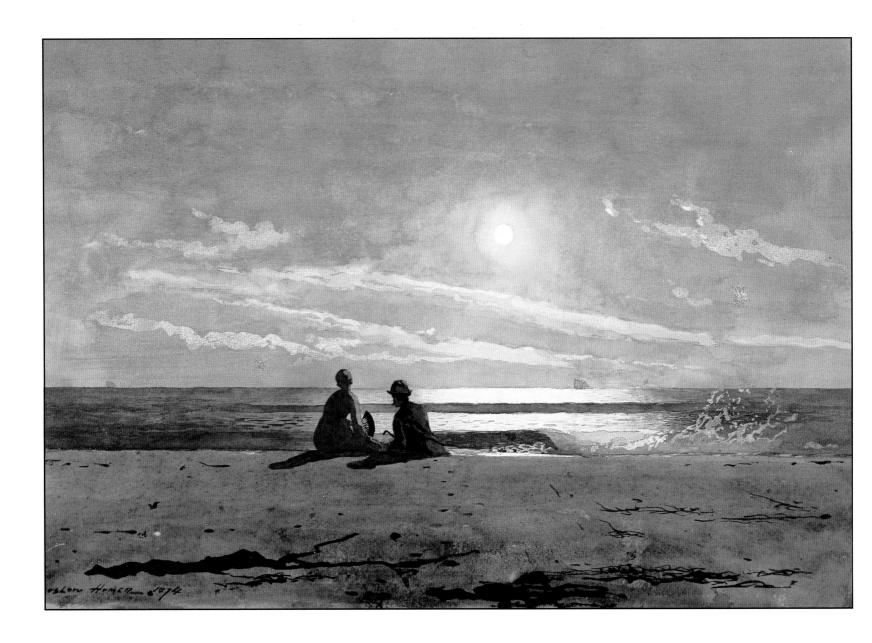

PLATE 7 *Moonlight,* 1874

Watercolor and gouache, 14 x 20 in.
Canajoharie Library and Art Gallery
Canajoharie, New York

What are the boasted glories of the illimitable ocean?
A tedious waste, a desert of water, as the Arabian
calls it. No doubt there are some delightful scenes.
A moonlight night, with the clear heavens and the
dark glittering sea.

—CHARLES DARWIN,
The Voyage of the Beagle, 1839

GLOUCESTER

Homer's initial visit to this fishing port, from June through July of 1873, was the occasion for his wholehearted embracing of watercolor.[5] Where he previously had used the medium for illustration, it now became an end in and of itself, even though some of the Gloucester sheets were eventually engraved for the weeklies.

This stay in Gloucester represented a significant stage in Homer's progress toward becoming a great painter of the sea—just as significant, in my reading of his career, as his long stay on the coast of England seven years later. Homer studied the goings-on in Gloucester Harbor in a wonderful series of watercolors and oils, taking particular pleasure in painting children busy at a variety of shoreline activities. They play among the rocks, make toy boats, arrange a clambake, or seesaw with a wooden plank balanced on a rock; they raid seabirds' nests; they tend to babies; they pick berries; they sit—as in the lovely *Boy in a Boatyard*—surrounded by the trappings of the fishing fleet.

A well-known oil from this time, *Dad's Coming,* slips over into the sentimental in its portrayal of a mother with baby and young son waiting hopefully on the shore for the father's return. While clearly more maudlin, a stanza from "Gloucester Harbor," a poem of the period by Elizabeth S. P. Ward, exploits sentiment in a similar fashion:

Forever from the Gloucester winds
The cries of hungry children start.
There breaks in every Gloucester wave
A widowed woman's heart.

This type of picture earns Homer the title "Genre Painter," which is not so bad a fate if one pulls it off as neatly as he does.

Boy in a Boatyard, 1873
Watercolor, tempera, and graphite on wove paper
mounted on board, 7 7/16 x 13 5/8 in.
Portland Museum of Art, Portland, Maine

But Homer soon took up more substantial fare and in the process weaned himself from the illustrated journals, submitting his last drawings to *Harper's Weekly* in 1875.

It was also at Gloucester that Homer began to master one of his favorite motifs, sea vessels. He had always accented his horizons with schooners and the like, but now he brought the subject to the forefront, studying the curving, tilting shapes of dories and sloops. As Thomas Eakins once wrote, "I know of no prettier problem in perspective than to draw a yacht sailing."[6] His contemporary would meet that challenge throughout his life, from the sleek catboat depicted in *Breezing Up*, 1876 (Plate 8), to the sloop pictured in what is considered Homer's last watercolor, *Diamond Shoal*, 1905.[7]

On a return trip to Gloucester in 1880, Homer spent the summer on Ten Pound Island situated in the middle of the harbor. He produced numerous watercolors, some of them of subjects he had tackled before. Of greatest interest is a remarkable series of sunsets and nocturnes in which he embraced the atmospherics of a given view and, in doing so, pushed beyond realism in a manner akin to Whistler's tonal landscapes or Turner's more vaporous sketches. As Helen Cooper has pointed out, the critics of the day were astonished by these pieces, in large part due to the sea change that they represented in Homer's aesthetic. Brilliant poetic compositions, they continue to amaze to this day.

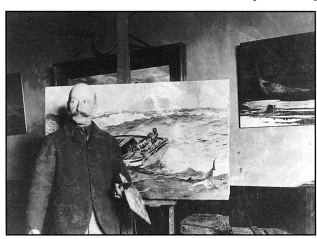

Winslow Homer at His Easel with The Gulf Stream *in his Painting Room at Prout's Neck, Maine*
Photographer unknown
Silver print
Gift of the Homer Family, 1964.69.179.9
Courtesy Bowdoin College Museum of Art, Brunswick, Maine

PLATE 8 *Breezing Up (A Fair Wind)*, 1876
Oil on canvas, 24¹/₈ x 38¹/₈ in.
Gift of the W. L. and May T.
Mellon Foundation
© 1995 Board of Trustees,
National Gallery of Art, Washington

When he [Homer] attacked a theme he gave it its full value, but never let it encroach upon the integrity of his technique. His art was beautifully balanced. You admire it for its own sake, yet this does not keep you from admiring its subject. Indeed, the very perfection of the equilibrium he established gives to each phase of his work the fullest possible force. Thus, while his technique is of the highest interest, nature speaks through his work with a peculiar richness and fullness.

—ROYAL CORTISSOZ,
New York Tribune, February 19, 1911

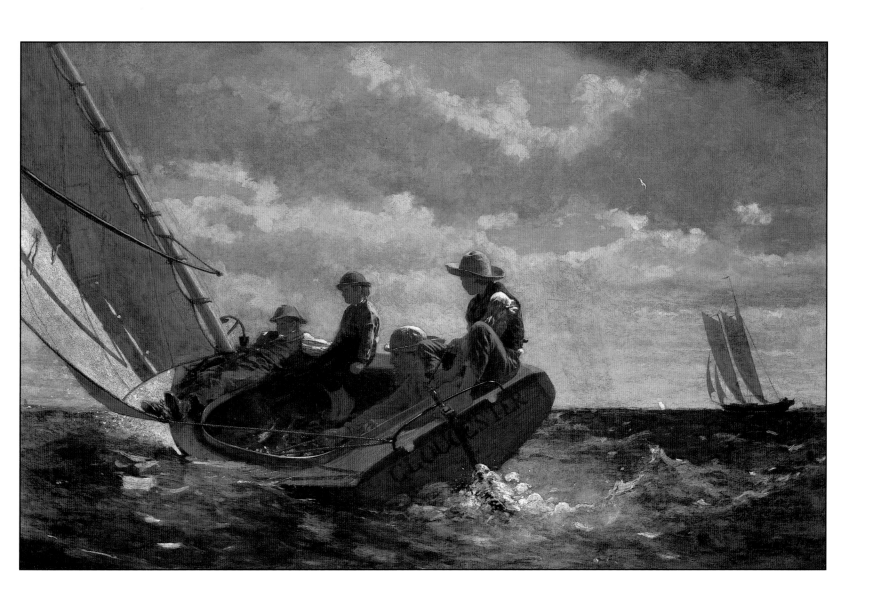

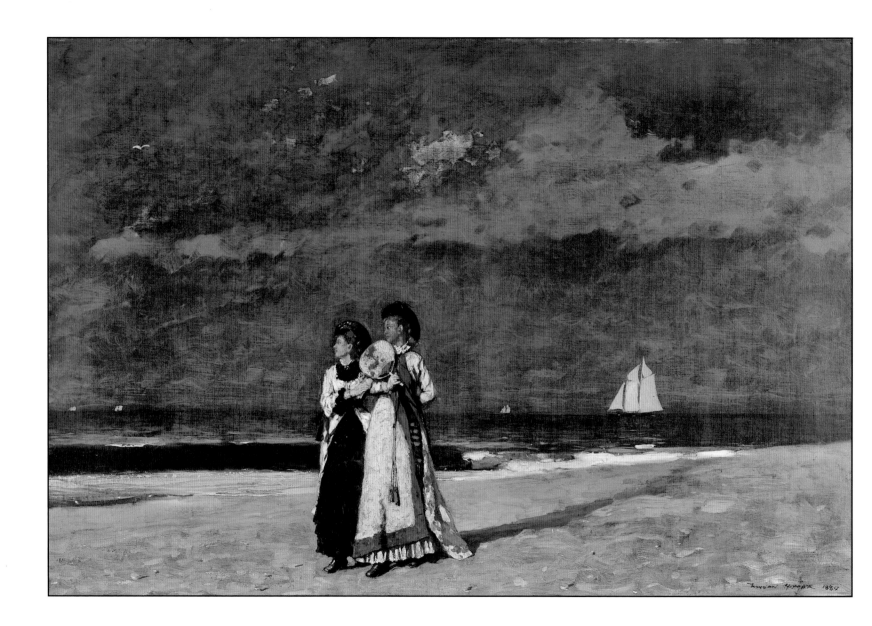

PLATE 9 *Promenade on the Beach,* 1880
Oil on canvas, 20¹/₄ x 30¹/₈ in.
Museum of Fine Arts,
Springfield, Massachusetts
Gift of the Misses Emily and
Elizabeth Mills in Memory of
their Parents, Mr. and Mrs. Isaac Mills

Homer was a leader in his craft because he saw what
he loved, loved what he saw, and placed the result
before us in such a way that we forget to analyze but
remain to regard with ease and affection.

—HOMER SAINT-GAUDENS,
Homer Centenary Exhibition,
Carnegie Institute, 1937

PLATE 10 *Sunset Fires,* 1880
Watercolor, $9^3/_4$ x $13^5/_8$ in.
The Westmoreland Museum of Art,
Greensburg, Pennsylvania
William A. Coulter Fund

The freedom from intrusion which he [Homer] found in this little spot [Ten Pound Island in Gloucester Harbor in 1880] was precisely to his liking, and here he painted a large number of watercolors of uniform size, but of a wide range of boldly conceived and vigorously executed subjects. No experiment, however fraught with risk of failure, had any terrors for him. He painted absolutely as he saw, entirely unafraid, caring for nothing so much as his freedom to express himself with unfettered independence.

—J. Eastman Chase,
"Some Recollections of Winslow Homer," *Harper's Weekly,* October 22, 1910

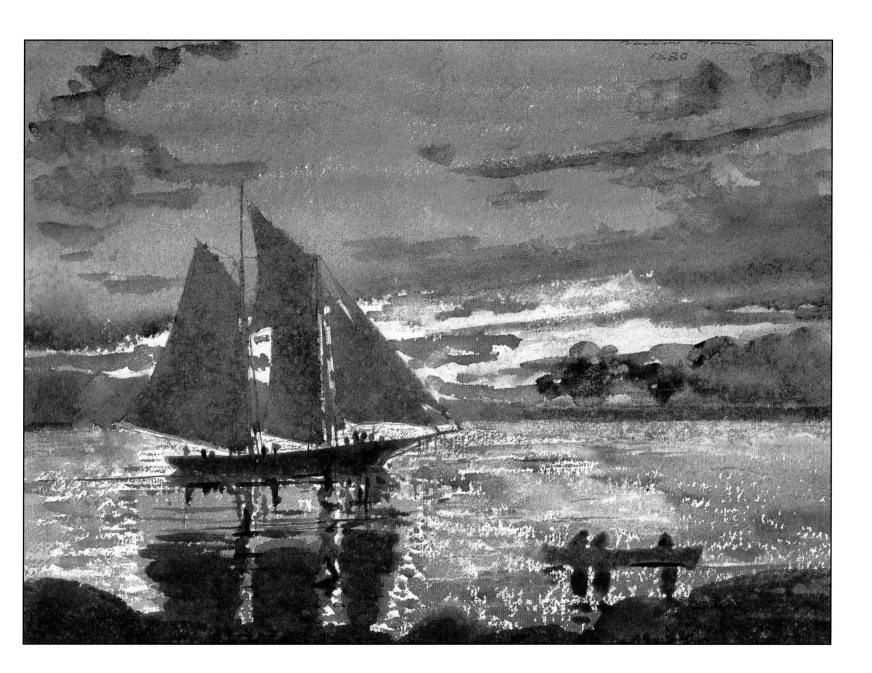

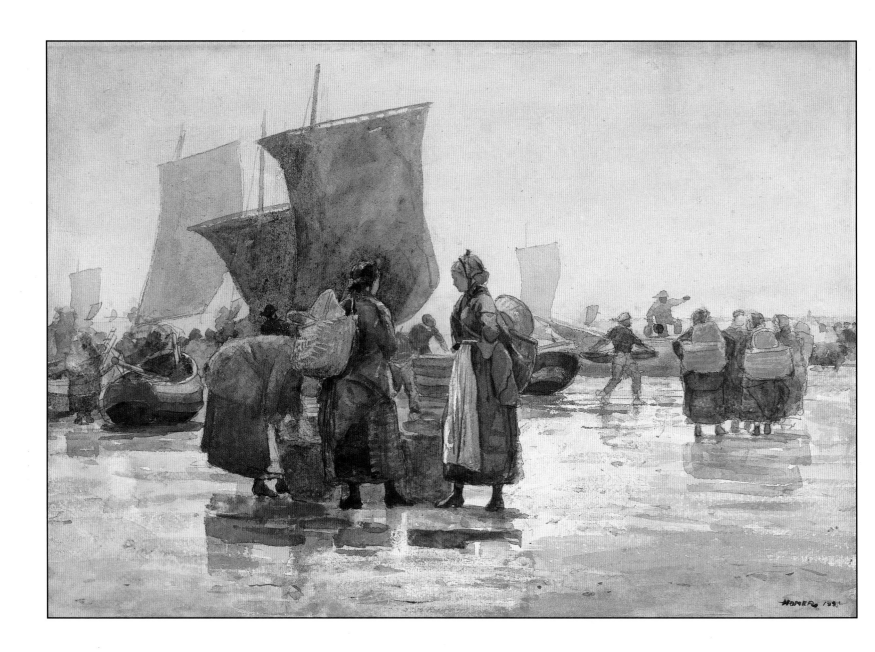

PLATE 11 *Fisherfolk at the Beach*
at Tynemouth, 1881
Watercolor, 13½ x 18½ in.
© Addison Gallery of American Art,
Phillips Academy, Andover, Massachusetts

In England [Homer] . . . painted figures, posing them and
working out every detail until he was satisfied he could do
no more; then took his canvas and models to the seacoast,
where, as he expressed it, "I would in a couple of hours,
with the thing right before me, secure the truth of the
whole impression."

—JOHN BEATTY,
cited by Lloyd Goodrich, *Winslow Homer,* 1944

PLATE 12 *Watching the Tempest,* 1881
Watercolor over graphite
on white paper, 13$^7/_8$ x 19$^7/_8$ in.
The Fogg Art Museum,
Harvard University Art Museums,
Cambridge, Massachusetts
Bequest of Grenville L. Winthrop

I have but few companions on the shore,
 They scorn the strand who sail upon the sea;
Yet oft I think the ocean they've sailed o'er
 Is deeper known upon the strand to me.
The middle sea contains no crimson dulse,
 Its deeper waves cast up no pearls to view;
Along the shore my hand is on its pulse,
 And I converse with many a shipwrecked crew.

—HENRY DAVID THOREAU,
"The Bay's Edge"

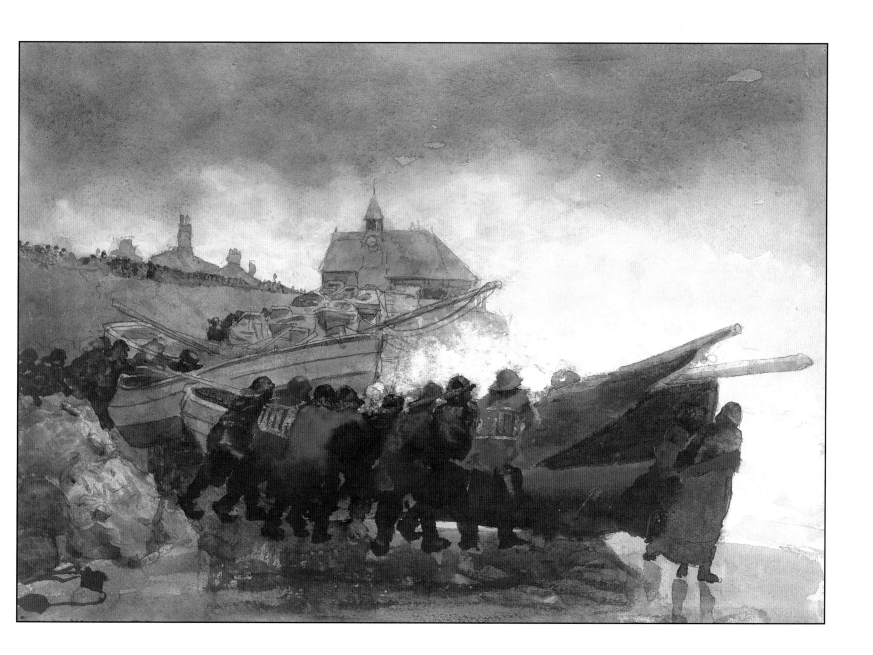

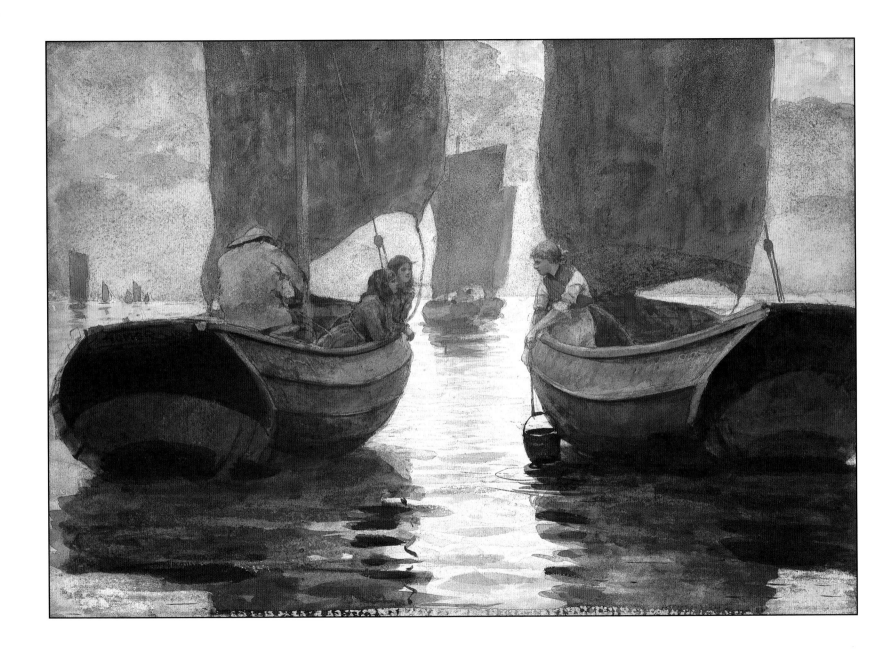

PLATE 13 *An Afterglow,* 1883
Watercolor over graphite,
15 x 21¹⁄₂ in.
Museum of Fine Arts, Boston
Bequest of William P. Blake in
memory of his mother,
Mary M. J. Dehon Blake

*The dignity of these landscapes and the statuesque
impressiveness and sturdy vigor of these figures,
translated by the strong sincerity of [Homer's]
brush, prove an originality of mood, a vigor of
conception, and a sort of stern poetry of feeling to
which he had never reached before.*

—MARIANA GRISWOLD VAN RENSSELAER,
Century Magazine, November 1883

AN ENGLISH SOJOURN

*There is a mental and moral kinship between Great Britain and America. . . . There is no reserve
nor coolness in our love and admiration for their sea-girt home where our forefathers once lived.*
—Henry van Dyke, "A Certain Insularity," 1921

Homer's nearly two-year stay in England from 1881 to 1882 is widely acknowledged as a
turning point in his career, a time of technical advancement in the development of what
would be his major theme, the seacoast.

The reasons proffered for his going abroad vary, from a desire to study English academic
painting to a need for freedom and space. Certainly there also was the natural kinship that
van Dyke invokes. In Homer's day, numerous poems were being written to honor "mother
England," "fair England," etc. Americans had outgrown the anti-British sentiments of the
young rebel nation and had come to embrace the "sea-girt home" of their ancestors.

After a brief visit in London,
Homer moved to Cullercoats,
a small fishing village near
Tynemouth, due east of
Newcastle, on the northeastern
coast of Northumberland—
far, as it were, from the
madding crowd and hard by
the North Sea. He also visited
other coastal spots such as
Flamborough, with its
vertiginous cliffs, and
Scarborough, a name Homer
already knew from his first
visit, in 1875, to Prout's Neck,
located in Scarboro, Maine.

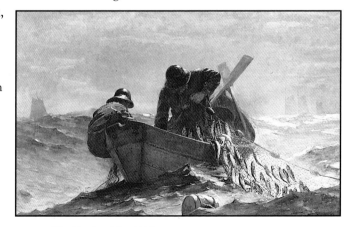

The Herring Net, 1885
Oil on canvas, 30¹⁄₈ x 48³⁄₈ in.
The Art Institute of Chicago
Mr. and Mrs. Martin A. Ryerson Collection, 1937.1039
Photograph © 1995 The Art Institute of Chicago
All rights reserved.

When men or women appear in Homer's pictures, they are often placed centrally, in mid-canvas or -sheet, with the coastal milieu surrounding them, underscoring their humanity—their vulnerability and their power when faced with the elements. The women of Cullercoats stand with fists on hips, not so much defiant as resolute in their stolid bearing. They hear voices from a cliff; they gather mussels and mend nets; they stand on a headland and watch the sea; they tote their children on their backs and walk out to wait for the fleet of fishing smacks to return. The fisherfolk are clearly attached to the sea, by the nets and baskets that sometimes threaten to overwhelm them, by the oars they man and the slickers they wear. Where the fishermen don their off-to-sea drab, their wives and sisters and daughters sport a touch of color, red stockings, a scarf or bright skirt or apron, the latter often billowing out in high winds.[8]

"English women are comely and *good*-looking," John Burroughs once wrote; their faces are "less clearly and sharply cut than the typical female face in this country, less

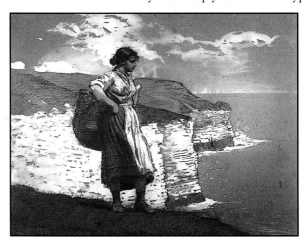

Flamboro Head, England, 1882
Watercolor, 17³/₄ x 24 in.
The Art Institute of Chicago
Mr. and Mrs. Martin A. Ryerson Collection, 1933.1240
Photograph © 1995 The Art Institute of Chicago

spirituelle, less perfect in form, but stronger and sweeter." While in England, Homer purchased mannequins to stand in for some of the female figures in his work, and sometimes they look it: uniformly robust, cut from the same hardy cloth, interchangeable.

When Homer showed a group of the Cullercoats watercolors in Boston in 1883, a critic for the *Evening Transcript* called him "both the historian and poet of the sea and sea-coast life." His reputation as an eminent marine artist was already established—and he still had Prout's Neck and the tropics ahead of him.

PLATE 14 *Inside the Bar, Cullercoats,* 1883
Watercolor on paper, 15³/₈ x 28¹/₂ in.
The Metropolitan Museum of Art, New York
Gift of Louise Ryals Arkell, in memory of her husband, Bartlett Arkell, 1954

The whole gamut of watercolor power, from the richness of elemental life depth and vividness to the density of storm darkness and human woe, and thence again to life light, joyousness, delicacy and subtle glow, is here [in Homer's Cullercoats watercolors] run with a strength and accuracy that few not seeing will believe it capable of. Indeed it seems to proclaim its capacity to be perhaps the most artistic of all art mediums when adequately handled.
—*Boston Evening Transcript,*
December 6, 1883

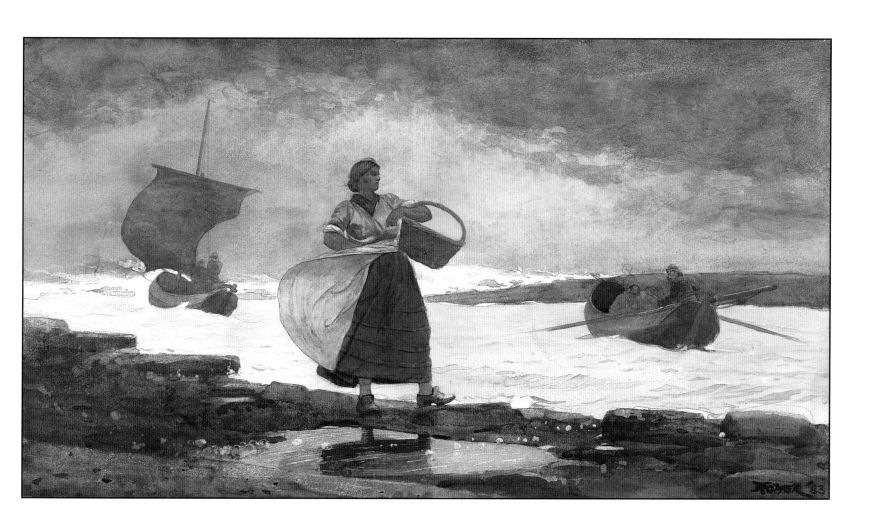

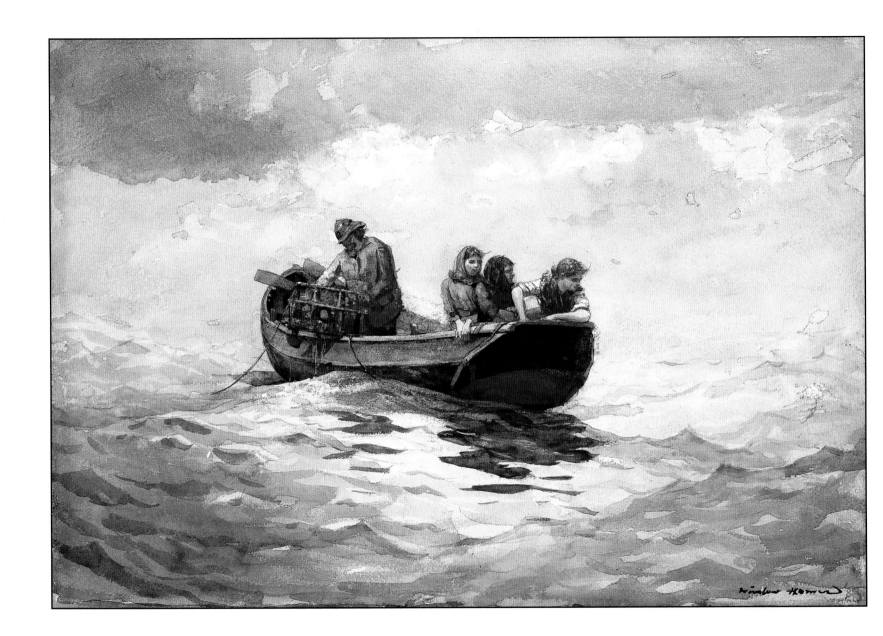

PLATE 15 *Crab Fishing*, 1883
Watercolor over graphite on
off-white wove paper, 14⁵/₈ x 21³/₄ in.
Worcester Art Museum,
Worcester, Massachusetts
Bequest of Grenville H. Norcross,
1937.13

In the marine sketches, color had been [Homer's]
chief concern . . . with no detail and fewest of rough
brushstrokes he gave us not only the intensified color
scheme of nature, but nature's movement too . . . he
had boldly omitted everything that could not serve
his purpose . . . and then unsatisfied by the brilliant
hues of nature, had keyed them to deeper force, made
them doubly powerful, the reds stronger and the
blacks blacker . . . he opened [his eye] to the full force
and beauty of certain effects, and filled for us the sky
of every future stormy sunset with memories of how
his brush had interpreted its characteristic beauty.

—Mariana Griswold van Rensselaer,
Century Magazine, November 1883

PLATE 16 *The Life Line,* 1884
Oil on canvas
28³/₄ x 44³/₈ in.
Philadelphia Museum of Art
George W. Elkins Collection

*At this stage of his career Homer preferred to paint from live models, but in this case [*The Life Line*] he could not get anyone to pose for him in the half-prone position he wanted. Perhaps the Scarboro [Maine] girls had felt it would be immodest; perhaps the rather proper Homer felt diffident about asking them. He called into service one of several small manikins he had purchased at Tynemouth. Using a wooden bird perch for the breeches buoy, he posed the doll at the desired angle and held it with a garter band, which is still tied to the arm of the figure. The clothing is fastened back to look windblown, and the many pinholes show how Homer experimented with various arrangements. But in spite of this artificial model, his painting is a miracle of dramatic power and the female figure incredibly real. Homer sent the final version of the painting to the National Academy Exhibition in the spring of 1884, where it was greatly admired.*

—PHILIP C. BEAM,
Winslow Homer at Prout's Neck, 1966

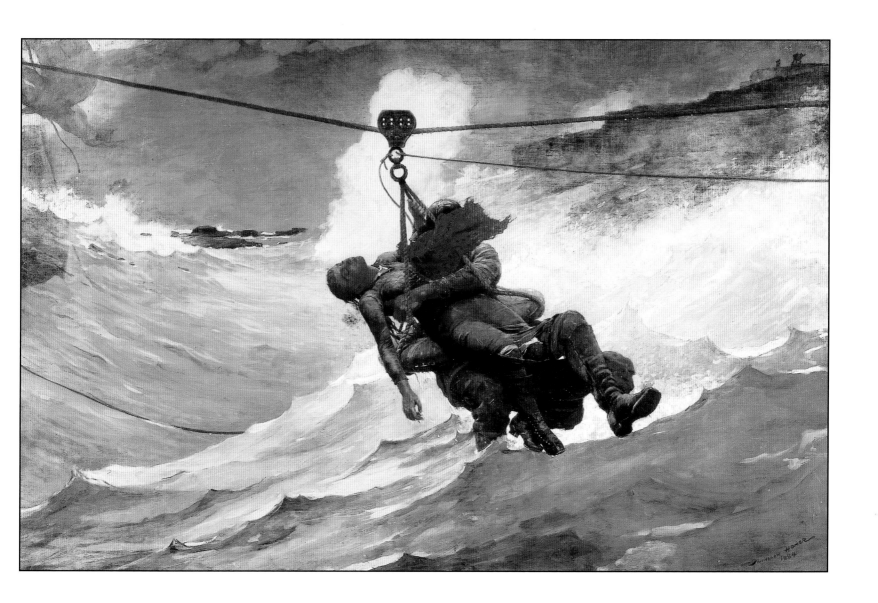

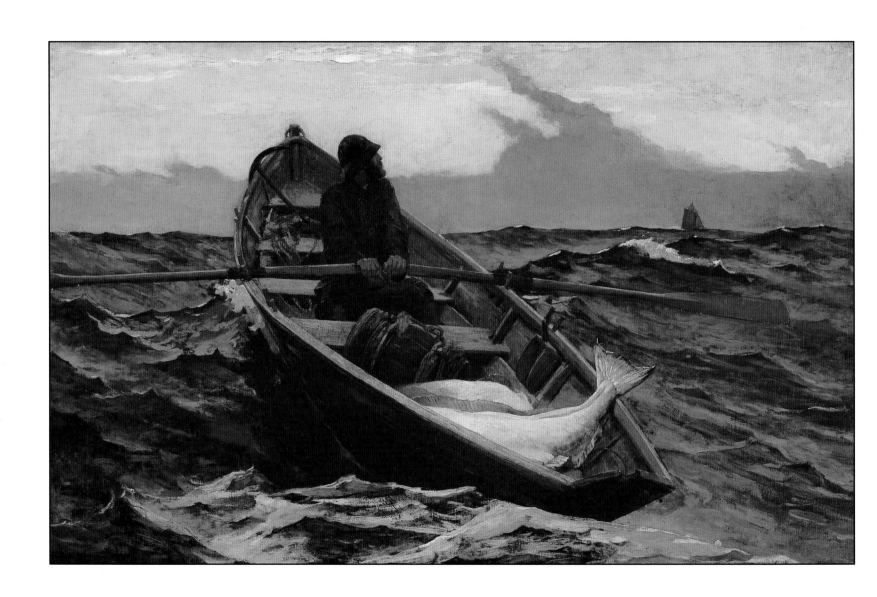

PLATE 17 *The Fog Warning,* 1885
Oil on canvas, 30 x 48 in.
Museum of Fine Arts, Boston
Otis Norcross Fund

Men who are accustomed to danger occupy a mental attitude towards it that has no room for melodramatic pose. Simple, sober, the unconscious hero of the picture [The Fog Warning] *turns to get the bearings of his schooner as he bends to his oars with all the steadiness of a man who has a long way to row and who must neither waste his strength in spurts nor lose his head. Small amidst the waves of the Atlantic looks his dory, far away seems the vessel, hard and cruel is the complexion of the sea. . . .*

—WILLIAM HOWE DOWNES,
"American Paintings in the Boston Art Museum," *Brush and Pencil*

PLATE 18 *Glass Windows, Bahamas,*
 c. 1885
 Watercolor over pencil,
 $13^{15}/_{16}$ x $20^{1}/_{16}$ in.
 The Brooklyn Museum
 Museum Collection Fund
 and Special Subscription

I prefer every time a picture composed and painted out-doors. The thing is done without your knowing it. Very much of the work now done in studios should be done in the open air. This making studies and then taking them home to use them is only half right. You get composition, but you lose freshness; you miss the subtle and, to the artist, the finer characteristics of the scene itself.

I tell you it is impossible to paint an out-door figure in studio-light with any degree of certainty. Out-doors you have the sky overhead giving one light; then the reflected light from whatever reflects; then the direct light of the sun; so that, in the blending and suffusing of these several illuminations, there is no such thing as a line to be seen anywhere.

—WINSLOW HOMER,
The Art Journal, 1880

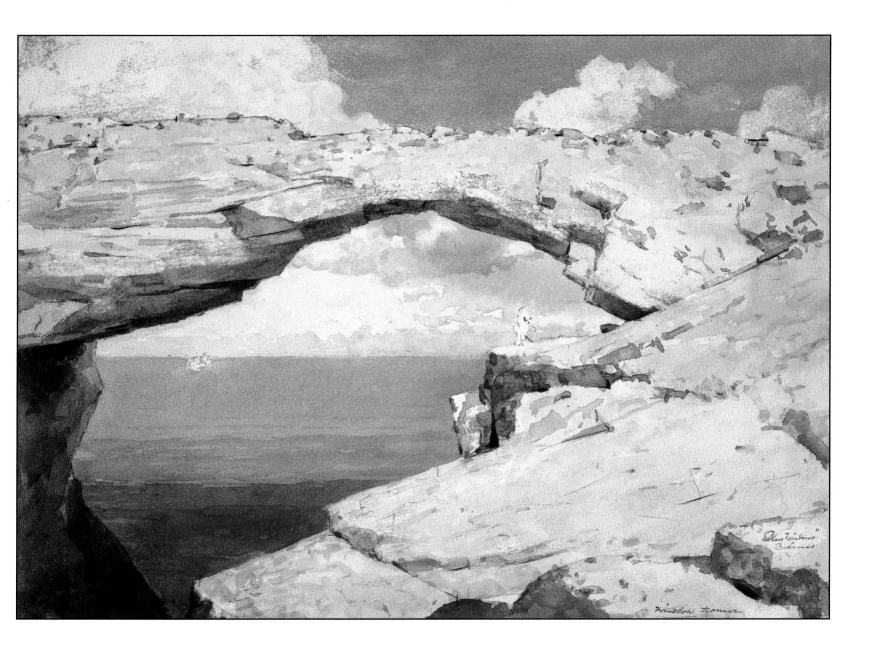

"Glass Windows"
Bahamas

Winslow Homer

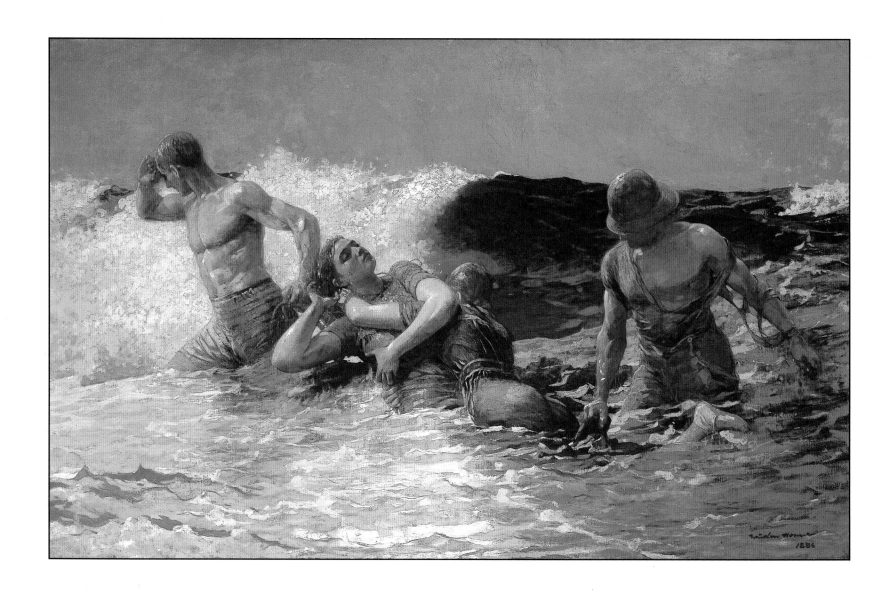

PLATE 19 *Undertow*, 1886

Oil on canvas, 29^{7}/$_{8}$ x 47^{5}/$_{8}$ in.
Sterling and Francine Clark
Art Institute,
Williamstown, Massachusetts

East Wind

There is a lingering northeast wind that sends
Corroding chill into the atmosphere,
Driving unlighted waves to futile ends
On unresponsive rocks. Fog rolling near
Blots out the sun. My sloopboat barely crawls.
Off shore a tossing bell buoy, clanging, plies
Incessant warning; and the cold sea walls
Grow ominous when a bulging comber flies
Savagely toward my bow. I quickly throw
The anchor, strain each nerve, and listening, feel
Boats all about me in distress that know
How breakers close at hand may suddenly steal
Up on the fleet and crush us at one blow,
Dooming our fortunes to the undertow.

—WILBERT SNOW

PROUT'S NECK: THE PROMISE OF SOLITUDE

I deny that I am a recluse as is generally understood by that term, neither am I an unsociable hog.
—Winslow Homer, letter to Louis Prang, December 30, 1893

In a sketch of his uncle's life, Charles L. Homer once wrote that upon his return from England Winslow "turned his back on New York and jury duty which he loathed and lived the rest of his life a few hundred yards from the sea, quite alone in a studio made from the stable on his father's place." Settled at Prout's Neck, Charles relates, Homer "painted the seas in all its moods and fished for recreation."

Part of Prout's Neck's allure was the promise of solitude.[9] Something his friend, fellow artist John Twachtman, wrote to J. Alden Weir in 1891 expresses a sentiment Homer himself might have voiced: "To be isolated is a fine thing and we are nearer then to nature." At the same time, as John Wilmerding has written, Homer's stays on Ten Pound Island and in Cullercoats "had given him time . . . to realize that such withdrawal was conducive for the creation of his best work."

This need for seclusion has been linked to Homer's Yankee heritage. Historians have made much of his Yankeeness, nailing the man to the regional wall. Tales have sprung up to encourage this reading: "A fierce Yankee was Homer," Marsden Hartley wrote, "keeping a shotgun behind his door for years against the local invader of his property"; and Alexander Eliot relates that the painter "put a sign reading COAL BIN on his studio door to throw would-be visitors off the track."

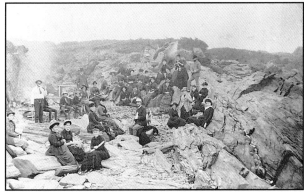

Winslow Homer and Family and Friends at Corn Roast,
Kettle Cove, Prout's Neck, Maine
Photograph by Simon Towle
Silver print
Gift of the Homer Family, 1964.69.177.17
Courtesy Bowdoin College Museum of Art, Brunswick, Maine

In *Winslow Homer at Prout's Neck*, Philip Beam did his best to correct what is for the most part a caricature of the artist, and yet our vision of Homer, the man, continues to be shaped by this sort of anecdote.

In the photographs of the artist that exist, he is at times a bit blurred or hard to see, as if he were avoiding the camera, unwilling to miss a sunset or a gale raging outside his studio on Prout's Neck. In the photo *Winslow Homer and Family and Friends at Corn Roast, Kettle Cove, Prout's Neck, Maine,* the artist sits at the way back, beyond the picnickers with their cobs of corn. He wears a straw boater, and the sideshow mustache he sports seems to swallow the lower part of his face, which is turned in profile to the photographer.

In that lead-like tone that silver prints of that vintage have, Kettle Cove seems a somewhat forbidding place, not the optimal site for an outing (for contrast, see the sumptuous setting of Jerome B. Thomson's c. 1850 oil *A "PicNick," Camden, Maine* in Boston's Museum of Fine Arts). It couldn't have been particularly comfortable, posing for Simon Towle, a photographer from Lowell, and yet this crowd of bulkily dressed women and slightly natty men seem completely at home—except perhaps Homer, who looks ready to slip away, to his studio or to some headland far from society where he can study the sea.

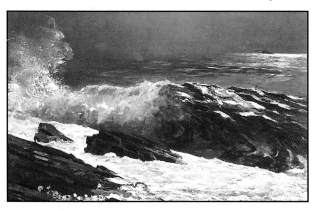

Sunlight on the Coast, 1890
Oil on canvas, 30¼ x 48½ in.
The Toledo Museum of Art
Gift of Edward Drummond Libbey, 1912.507

PLATE 20 *A Summer Night,* 1890
Oil on canvas, 30¼ x 40⅛ in.
Musée d'Orsay, Paris

When the time came that summer to put his knowledge of moonlight effects to work, in A Summer Night, *he knew what he was about. As happened so often with Homer, he saw a subject that appealed to him, made up his mind how he wanted to treat it, gathered the various elements over a period of days or even weeks, and then combined them into a final composition. Homer was no human camera; he did not capture a scene in an instant with brush and pigment, but synthesized subject matter, impressions, technical means, and remembered knowledge into a perfectly harmonious result. And his ability was such that the final design impresses us as being so real, so natural, so unstudied that we find difficulty believing it was built up step by step, piece by piece.*

For the two dancing figures in A Summer Night *Homer posed Maude Googins Libby and Cora Sanborn on an old float at Ferry Beach [on Prout's Neck]. For about an hour every day through a whole week he made rapid sketches of the two girls, moving around them, studying them from every aspect. In the finished oil the two girls dancing in front of the moonlit dancing waves lend just the right quality of vitality to contrast with the rock-like silhouetted figures at the right.*

—PHILIP C. BEAM,
Winslow Homer at Prout's Neck, 1966

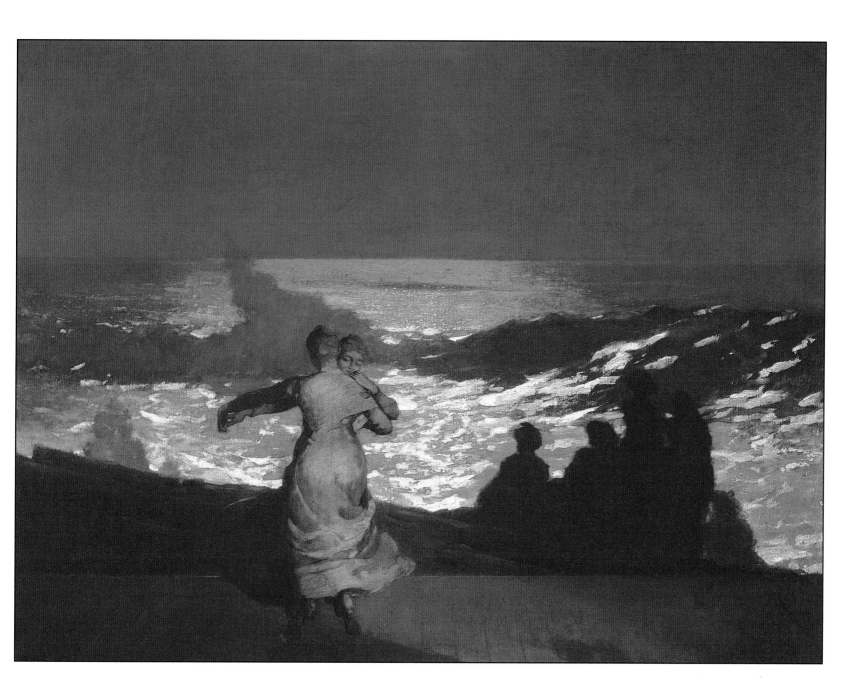

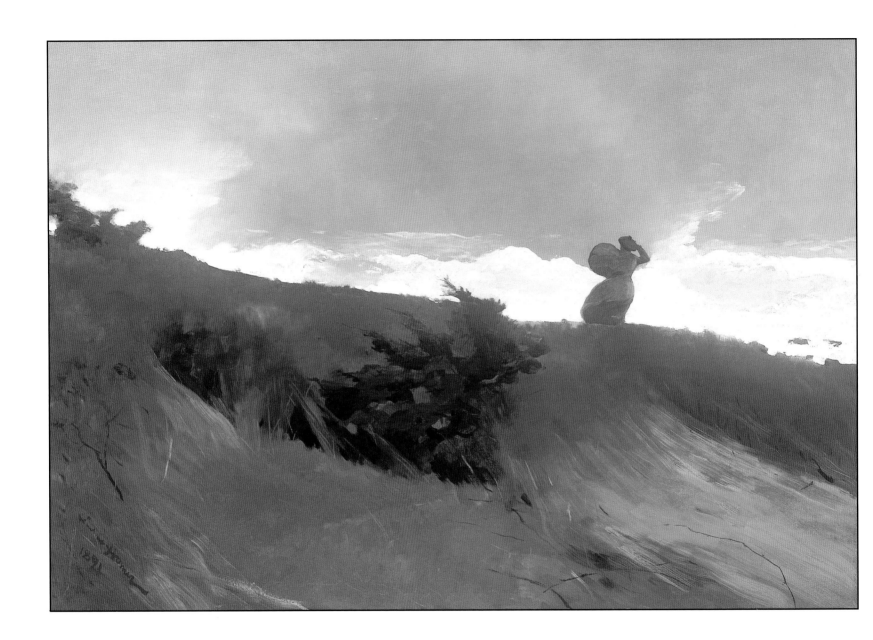

PLATE 21 *The West Wind,* 1891
Oil on canvas, 30 x 44 in.
© Addison Gallery of
American Art,
Phillips Academy,
Andover, Massachusetts
Gift of anonymous donor

Charles L. Homer told me that sometime before painting The West Wind, *Winslow had been dining with John La Farge in New York; the two were devoted friends but had many conflicting ideas about art, especially in the field of color. La Farge criticized Winslow for using too much brown and said his paintings were too dull-toned. Unlike Homer, he was an avowed admirer of European techniques, especially the rich color of the Venetians. Winslow wagered him a hundred dollars that he could paint a picture in browns which would be accepted and admired by critics and the public as well. After Reichard, the [New York] dealer who exhibited* The West Wind, *had reported to Homer the obvious popularity of the work, Winslow wrote to La Farge,* "The West Wind *is brown. It's damned good. Send me your check for $100."*

—Philip C. Beam,
Winslow Homer at Prout's Neck, 1966

PLATE 22 *Fox Hunt*, 1893
Oil on canvas, 38 x 68½ in.
The Pennsylvania Academy
of the Fine Arts, Philadelphia
Joseph E. Temple Fund

[Homer] was back [at Prout's Neck] toward the beginning of March, and immediately asked Roswell Googins, a good hunter, to get him a dead fox and some dead crows. Ros supplied the crows, but another hunter got a fox first and delivered it to Homer.

Winslow arranged the crows as if in flight on a snowdrift outside the studio window and let them freeze stiff. Googins told me how he and the artist with sticks and string posed the fox in a running attitude. With fox and birds frozen in position, and the background rocks clearly in view, Homer set to work on The Fox Hunt. *Unfortunately he had started a little late in the season, and Mrs. Charlotte Stevens described his irritation because "the weather keeps thawing, and the crows get limp." After he had made some progress he asked the opinion of Elbridge Oliver, the Scarboro stationmaster, about the crows in the painting. Oliver was not one to flatter Homer or anybody else, and his criticism was terse and honest: "Hell, Win, them ain't crows." Homer was as honest a painter as Oliver was a critic; without a word he picked up a brush and painted them out.*

He returned with Oliver to Scarboro station with some corn, and for the next three days they lured in crows, while Win made innumerable sketches on telegram blanks. [He went] back to the studio, this time to paint the crows as they appear today, but he did not consider them finished until he had called in Oliver again and got his approval. When Mrs. Munroe and Winslow's father came in May to open the Ark, Homer showed them the completed painting, and she remembered that the artist cleared off the mantel and displayed the picture to obtain their impression of it.

—PHILIP C. BEAM,
Winslow Homer at Prout's Neck, 1966

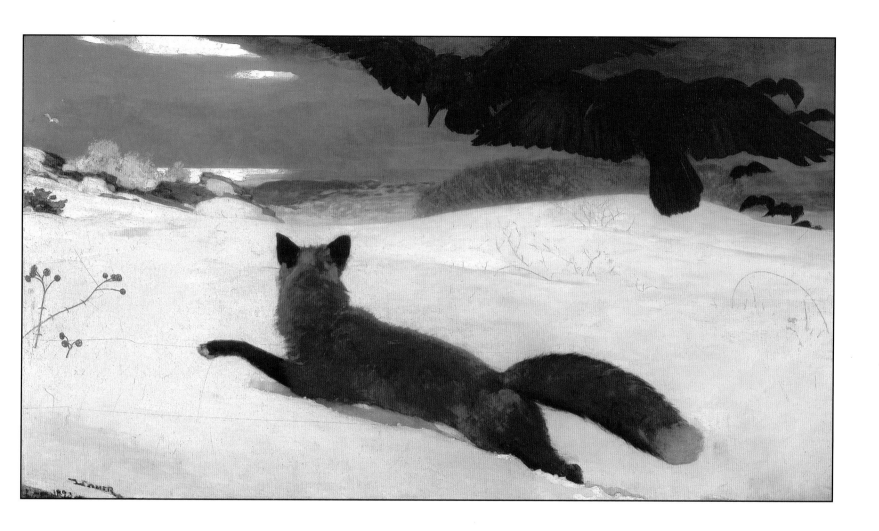

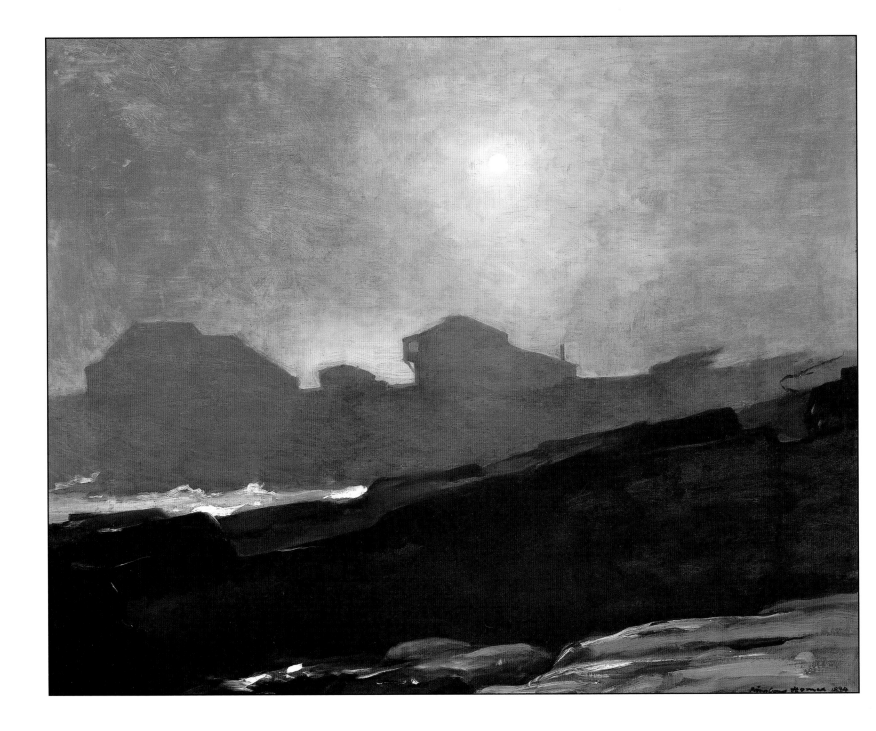

PLATE 23 *The Artist's Studio in an Afternoon Fog,* 1894
Oil on canvas, 24 x 30 in.
Memorial Art Gallery of the
University of Rochester
R. T. Miller Fund

Winslow Homer looked straight through the vapor at the hard rock; he found in the leaden heaviness a most tremendously forceful idea.

—ROBERT HENRI,
The Art Spirit, 1923

PLATE 24 *The Wreck*, 1896

Oil on canvas, 30³/₈ x 48¹/₄ in.
The Carnegie Museum of Art,
Pittsburgh, Pennsylvania
Purchase, 96.1
Photograph: Richard Stoner

. . . and so the sky keeps,

For the infinite air is unkind,

And the sea flint-flake, black-backed
 in the regular blow

Sitting Eastnortheast, in cursed
 quarter, the wind;

Wiry and white-fiery and
 whirlwind-swivelled snow

Spins to the widow-making
 unchilding unfathering deeps.

—GERARD MANLEY HOPKINS,
"The Wreck of the *Deutschland*"

MASTER WATERCOLORIST

Watercolor is traditionally considered the most disobedient of mediums; so Eliot O'Hara titled one of his books on the subject, *Making Watercolor Behave*. In an essay on Homer, Robert Hughes describes the vagaries of the medium:

One has to work from light to dark, not (as with oils) from dark to light. It is hospitable to accident (Homer's seas, skies and Adirondack hills are full of chance blots and free mergings of color) but disaster-prone as well. One slip, and the veil of atmosphere turns into a mud puddle, a garish swamp.

Throughout his career, Homer adjusted his watercolor approach to suit the landscape. Thus, the Adirondack sheets are often filled with paint, much of it opaque, matching the views he painted of wood-surrounded lakes, while the watercolors of the Caribbean are marked by luminous washes that capture the expanses of water and the all-encompassing quality that light has in the islands.[10] In the last two decades of his life, Homer made a number of trips south, to Florida, the Bahamas, Cuba, and Bermuda, escaping the sometimes brutal cold of Prout's Neck. "[Homer's] watercolors of the tropics," Donelson Hoopes has written, "speak of the delight he found in the azure skies, the shimmering transparent shallows of the islands, and the warm overhead sun."

Gustave Courbet (French, 1819–1877)
The Waves, 1869
Oil on canvas, 59³/₈ x 29³/₄ in.
Philadelphia Museum of Art
The W. P. Wilstach Collection, donated by John G. Johnson, W'05-1-1

The artist also took an interest in the unusual rock formations on the islands, just as Courbet, Monet, and other artists had been attracted to the natural bridges formed by the cliffs at Etretat on the Normandy coast. And then there are his transcendent paintings of palm trees and his several renderings of tropical storms, whose fury he responded to as avidly as he did the awesome gales of the Maine coast.

Homer's vision of the tropics was not unlike that of Ernest Hemingway; a painting like *The Gulf Stream*, 1899 (Plate 28), calls to mind Hemingway's short novel *The Old Man and the Sea*. Both men were intrigued by that timeless match-up, man versus nature, and embraced the out-of-doors. Homer expressed this plainly and poetically in a letter he sent to his brother Charles in 1895: "The life I have chosen gives me my full hours of enjoyment for the balance of my life. The Sun will not rise, or set, without my notice, and thanks."

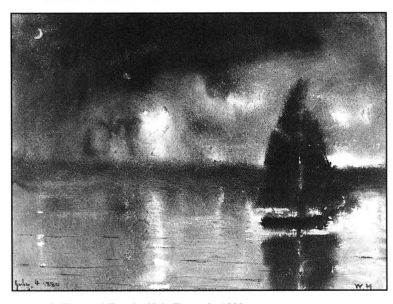

Sailboat and Fourth of July Fireworks, 1880
Watercolor and white gouache on white wove paper, 9⅝ x 13⅝ in.
The Fogg Art Museum,
Harvard University Art Museums,
Cambridge, Massachusetts
Bequest of Grenville L. Winthrop

PLATE 25 *Flower Garden and Bungalow, Bermuda*, 1899
Pencil and watercolor,
13⅝ x 20½ in.
The Metropolitan Museum
of Art, New York
Amelia B. Lazarus Fund, 1910

If this country has contributed anything distinctive to the craft traditions of painting, it is in the watercolor style that Homer founded.

—CLEMENT GREENBERG,
"Winslow Homer," 1944

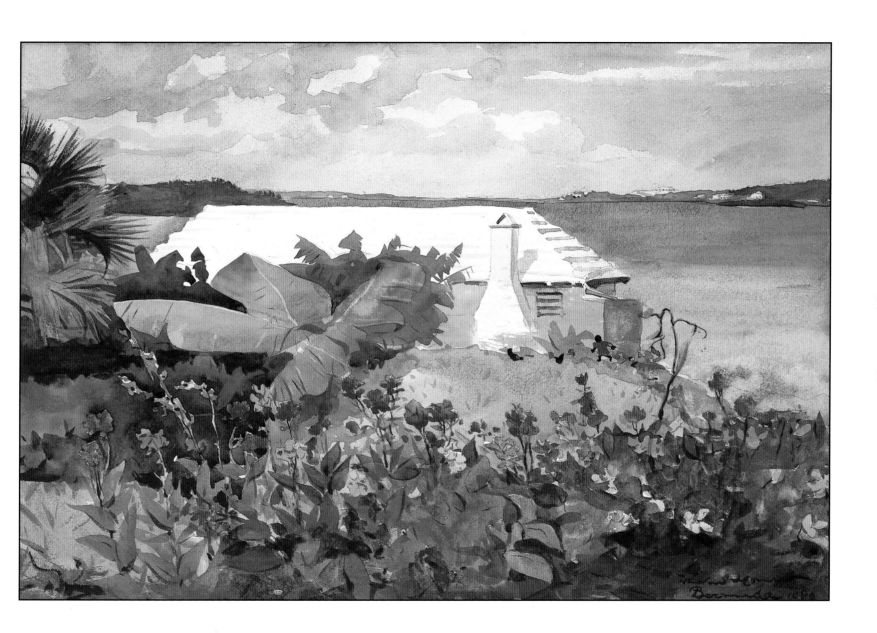

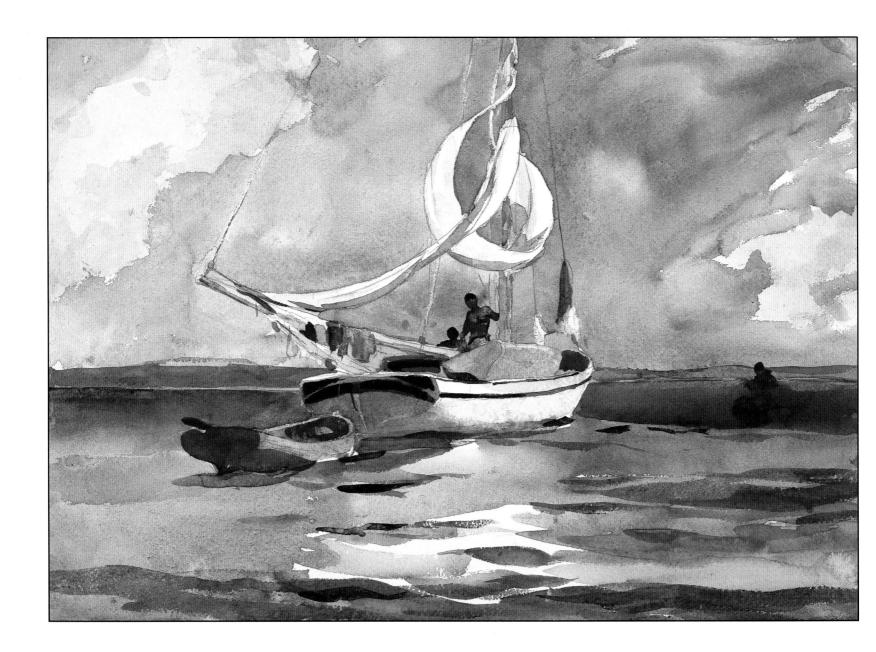

PLATE 26 *Sloop, Nassau,* 1899
Watercolor and graphite
on off-white wove paper
14$^7/_8$ x 21$^3/_8$ in.
The Metropolitan Museum of Art,
New York
Amelia B. Lazarus Fund, 1910

I think Bahamas the best place I have ever found.

—WINSLOW HOMER
to Louis Prang, October 18, 1905

PLATE 27 *The Light House, Nassau,* 1899
Watercolor over graphite on
medium, smooth off-white paper,
14$\frac{1}{2}$ x 21$\frac{1}{4}$ in.
Worcester Art Museum,
Worcester, Massachusetts

*The free life of the islanders and their masculine
beauty gave these [tropical] works, with all their
realism, a pagan spirit like that of Greek art.*

—LLOYD GOODRICH,
American Watercolor and Winslow Homer, 1945

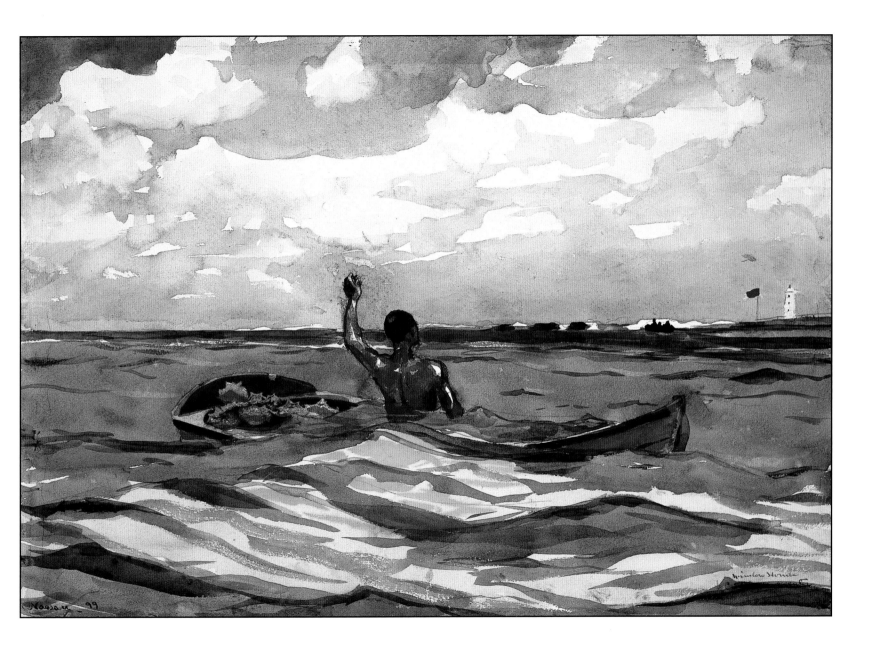

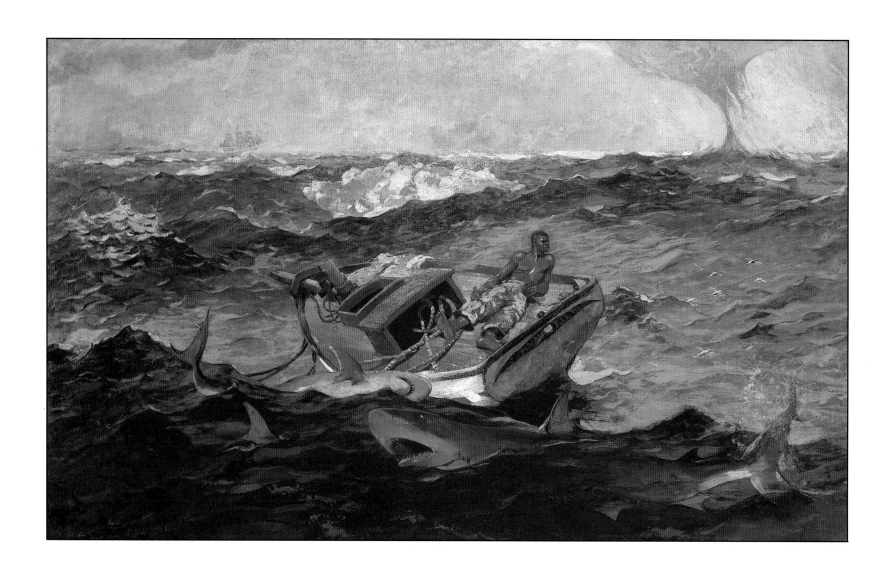

PLATE 28 *The Gulf Stream,* 1899
 Oil on canvas, 28$^1/_8$ x 49$^1/_8$ in.
 The Metropolitan Museum of Art,
 New York
 Wolfe Fund, 1906,
 Catherine Lorillard Wolfe Collection

Thursday, September 15th. *This morning the temperature and peculiar appearance of the water,
the quantities of gulf-weed floating about, and a bank of clouds lying directly before us, showed that
we were on the border of the Gulf Stream. This remarkable current, running north-east, nearly
across the ocean, is almost constantly shrouded in clouds, and is the region of storms and heavy seas.*

—RICHARD HENRY DANA JR.,
Two Years Before the Mast, 1840

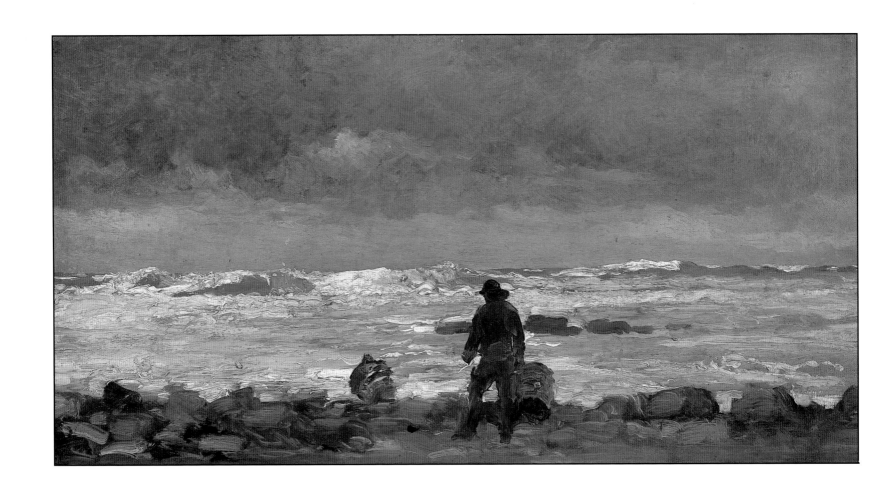

PLATE 29 *Rocky Coast,* c. 1883–1900
Oil on canvas, 14 x 27¹⁄₈ in.
Wadsworth Atheneum,
Hartford, Connecticut
The Ella Gallup Sumner and
Mary Catlin Sumner
Collection Fund, 1945.1

Ledges

These raw slabs of rock laid down
in creased oblongs, schists and squares,
in plateaus, in giants' stairs
with hollows and depressions cupping
pools and puddles from the last high tide,
in one a cautious crab among the barnacles,
another green with primal slime,
while below, the sea-wall steeply falls
into the bay that stretches toward the distant
sky—a view as desolate as when
these pink-tinged ledges thrust out of the sizzling
sea and cooled, until, at last
the sun's warmth made mysterious
migrations of dissolved
elements and nutrients compounded
in the earliest
self-begotten motions in the world.

—DANIEL HOFFMAN
Copyright © 1994 by Daniel Hoffman

HOMER'S LEGACY

Winslow Homer must be found to be a New Englander, of course; but a New Englander
on the national scale. He was of America and belongs to all the country.
—Booth Tarkington, 1936

One of Homer's great gifts to marine painting was his loosening up of the treatment of sea subjects, in both oil and watercolor. What Joyce Carol Oates has written of his Cullercoats pictures—that they "break . . . with the genteel tradition of American nature art"—might be said of many of the coast paintings of his maturity. His approach had the same liberating effect that method acting had on theater and cinema in the 1950s. If you want to paint the sea, he seems to have said, you have to live right alongside it.

You wouldn't catch Homer reenacting warship encounters or depicting biblical deluges in his canvases; his interests tended to be down-to-earth—or, better, down-to-sea. He did paint his share of shipwrecks, most notably *The Wreck of the Iron Crown,* 1881, and could involve his viewer directly in a sea drama, as in the 1883 watercolor *The Ship's Boat* or the famous *The Life Line* (Plate 16) and *Undertow* (Plate 19) canvases. Yet the calamities themselves are often only suggested, happening somewhere off the canvas, as in the masterful *The Wreck,* 1896 (Plate 24). Homer preferred to show the men scrambling for the lifeboats, the fisherwomen pensive with imagining sea disasters, or the aftermath, when the vessel lay riven upon the rocks.

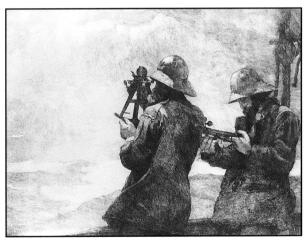

Eight Bells, 1887
Etching
The Metropolitan Museum of Art, New York
Harris Brisbane Dick Fund, 24.39.4

"What the influence of [Homer's] life and work upon the coming generation of American painters is to be, is a difficult question, which it is yet too early to settle," wrote William Howe Downes at the end of his biography of the artist, published in 1911, the year after Homer's death. Had he been a bit more alert, as numerous art historians have subsequently pointed out, Downes would have seen the artist's influence everywhere around him.[11] Even in his lifetime Homer had his followers, such as Leon Kroll, who visited the master at Prout's Neck. Kroll is reported to have been counseled, "Never put more than two waves in a picture; it's fussy." Beam cited Homer's advice to another artist, Wallace Gilchrist: "When you paint, try to put down exactly what you see. Whatever else you have to offer will come out anyway."

Artists of later generations—Robert Henri, Rockwell Kent, George Bellows, Edward Hopper, the Wyeths, among others—openly emulated Homer. In many cases we have written testimony to their admiration and, by inference, their indebtedness to Homer. Keeping in mind the tradition of the artist who admits no equal, even a few lines of tribute by one of them outweigh the thousands of pages of praise writ by historians and critics.

N. C. Wyeth went so far as to name his house in Port Clyde, Maine, "Eight Bells" after Homer's famous canvas. In a letter to his friend Sidney M. Chase, sent from Chadds Ford in 1910, the year Homer died, Wyeth paid his respects to the master:

I have come to realize that artistic expression only exists as a serious and valuable possession insofar as one makes it his own. We have such a remarkable example in Homer. He knew light and shade, values, drawing, etc., in common with others. Further than that, all he possessed was distinctly his.

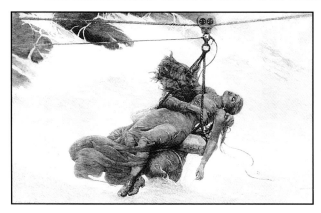

Saved
Etching, 16¾ x 27⅝ in.
The Metropolitan Museum of Art, New York
Harris Brisbane Dick Fund, 24.39.6

In Andrew Wyeth's case, one witnesses a direct passing down of aesthetic sensibility. As Homer was known to have waited long periods for the right weather conditions to finish a canvas, so Wyeth once noted that to paint *Wind from the Sea,* 1947, he had to wait two months for another wind from the west to study the blowing curtains that are the centerpiece of this canvas. "You can't make these things up," he told an interviewer. "You must see how it was"—words that might have issued from Homer's mouth.

Homer's art also broke a path for the American modernists. If one were able to put certain of his seascapes through an abstracting device, one might end up with Arthur Dove's *Ferry Boat Wreck,* 1931; John Marin's *My Hell-Raising Sea,* 1941; or Marsden Hartley's *Evening Storm, Schoodic, Maine,* 1942. These artists rendered Homer motifs with a new vocabulary and in doing so revivified the landscape tradition.

"Here the Sea is so damned insistent that houses and land things won't appear much in my pictures," Marin wrote in a letter to Alfred Stieglitz from Addison, Maine, on September 10, 1936. This insistence of the sea on the Maine coast seems to have driven Homer to respond in the way that he did. Living in close proximity to the full-fledged Atlantic, Homer fell victim—a very willing victim, mind you—to the ocean's ever-changing demeanor.

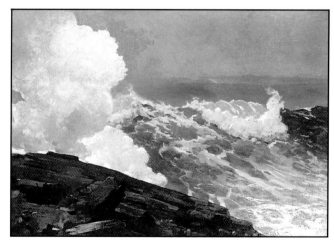

Northeaster, 1895
Oil on canvas, 34⅜ x 50¼ in.
The Metropolitan Museum of Art, New York
Gift of George A. Hearn, 10.64.5

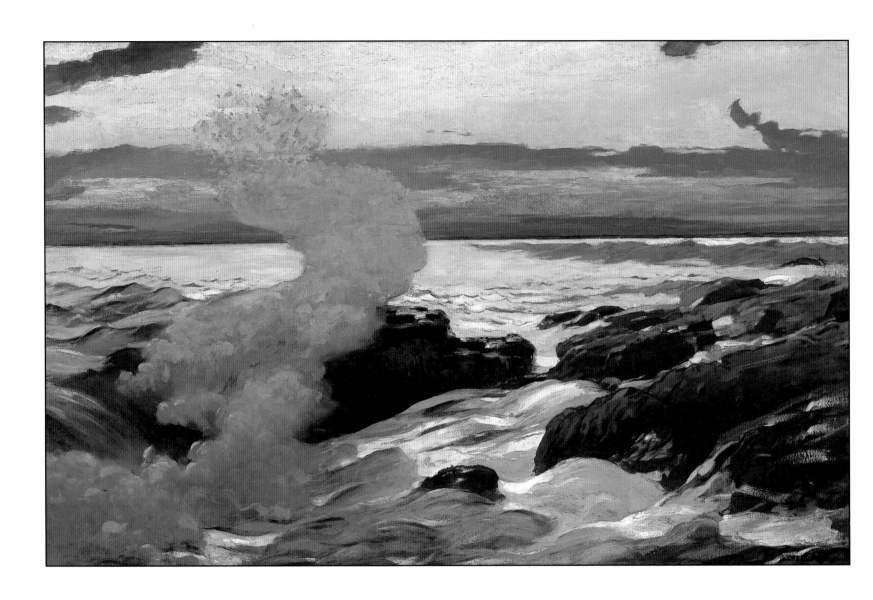

PLATE 30 *West Point, Prout's Neck,*
Maine, 1900
Oil on canvas, 30$\frac{1}{8}$ x 48$\frac{1}{8}$ in.
Sterling and Francine Clark
Art Institute, Williamstown,
Massachusetts

Near Checkley Point, Homer painted the brilliant
West Point, Prout's Neck. Across the flat stretch
of Saco Bay are the distant beaches of Pine Point
and Old Orchard and a sky illuminated by a
flaming sunset. The technical bravura with which
Homer painted this oil is based upon a confidence
that comes with years of experience. The waves
churning between the rocks are rendered in
conventions which he had evolved—amazingly
simplified impressions, yet perfectly convincing.
Like the best of the Japanese masters, Homer was
able to sacrifice reality, even physical possibility—
as in the sinuously curling plume of spray—for
aesthetic effect, without seeming implausible.
Our minds may tell us a wave could not behave
like this, but so delightful is the design that we
unconsciously feel it ought to.

—PHILIP C. BEAM,
Winslow Homer at Prout's Neck, 1966

PLATE 31 *Early Morning After a Storm at Sea*, 1902
Oil on canvas, 30¼ x 50 in.
© The Cleveland Museum of Art
Gift of J. H. Wade, 24.195

Homer never sought to "express himself."
He doubtless loathed the term. "Das Ding an
Sich"—the Thing Itself—he saw. He painted it.
And without the least concern—so we may
judge—as to whether what he did was art or
wasn't, just simply loved what he did, he
became the great and solitary master of
realism that he is.

—ROCKWELL KENT

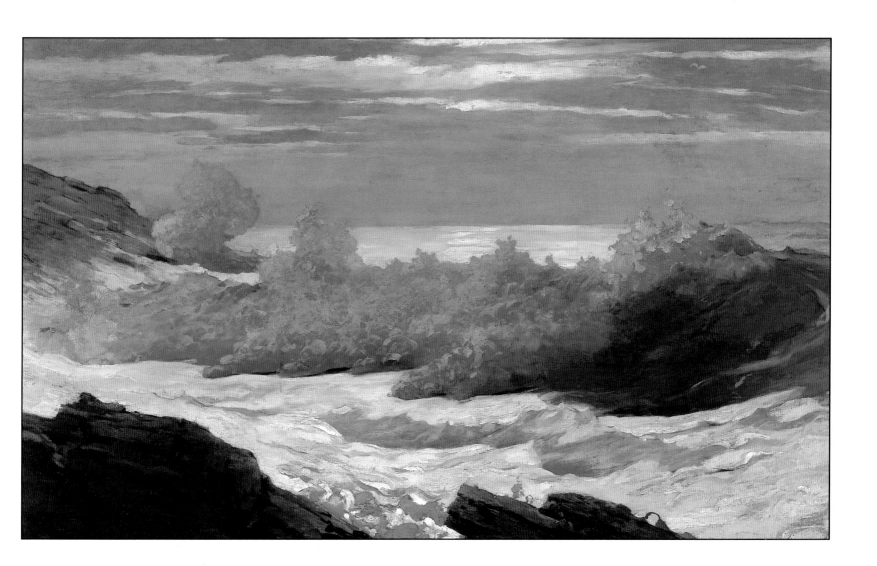

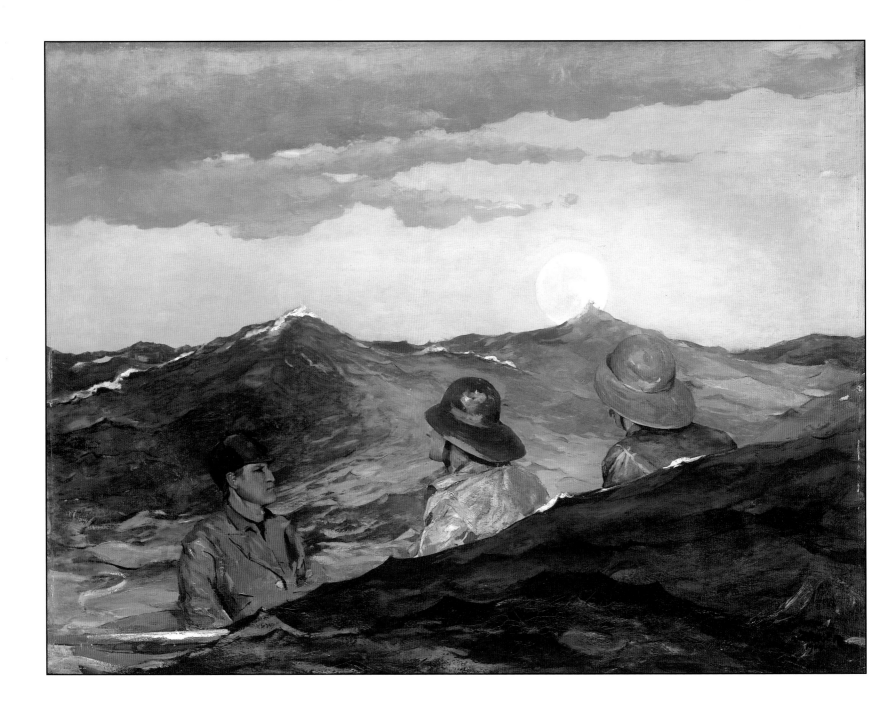

PLATE 32 *Kissing the Moon,* 1904
Oil on canvas, 30 x 40 in.

None of them knew the color of the sky.
Their eyes glanced level, and were fastened upon
the waves that swept toward them. These waves
were of the hue of slate, save for the tops, which
were of foaming white, and all of the men
knew the colors of the sea.

—Stephen Crane,
"The Open Boat"

EPILOGUE: A VISIT TO PROUT'S NECK

Driving south from Portland, one traverses Route 1, a predominantly commercial strip that follows the Maine coast from Kittery to Calais. Leaving the fast food motel world, you cross the Scarboro marshes, a lovely expanse of salt grasses and winding streams edged by deep woods.[12] All this time, as you approach that famed "neck" of·land that juts out into the water, you have little idea what you're in for. You pass clusters of condominiums, a new church that looks like a condominium, a few older, more typical New England dwellings, which are the odd men out—and then you enter the enclave.

In *Old Prout's Neck,* 1924, Augustus Moulton declared the colony "prominent still, . . . expanding upon the best modern lines." More critical is the appraisal found in *Maine: A Guide 'Down East,'* 1937, written by workers of the Federal Writers' Project of the Works Progress Administration: Prout's Neck, they write, is a "pretentious summer settlement."

The morning I drove down, I felt nervous, as if I were going to pay a visit to Homer himself. What would I say, how would I act, before the master? In my youth, I'd sought out rock stars at backstage entrances in New York City and always felt the fool when they actually showed up and I had little to say, except for exaggerated compliments about the performance. So I would babble on to Homer, "Your painting *The Life Line* is fantastic, that scarf obscuring the rescuer's face," or ask something silly like, "Did a wave ever swamp you as you painted on the rocks?"

Maine Coast
Oil on canvas, 30¼ x 44¼ in.
The Metropolitan Museum of Art, New York
Gift of George A. Hearn in memory of
Arthur Hoppock Hearn, 11.116.1

Fortunately for both of us, Homer wasn't there. But his sea was, and his rocks and his driftwood bobbing in the water and littering the shore. Parking at the Black Point Inn,[13] I walked the marginal way that hugs the edge of the neck, where there are cute signs signaling "rough going ahead." I got sprayed by the surf and rosy-cheeked by the stiff wind, which blew back wave foam in great sheets of spindrift. It was high tide, and the sea was all a rage, roiling and rushing and churning.

Prout's Neck is an exposed place; I have it from a sailor friend who knows the Maine coast that every mariner's guide frowns on anchoring off of it—and certainly the many pictures of wrecks and near-wrecks Homer painted there testify to the sea's nasty attitude. Many a Prout's Neck canvas has a Wagnerian forcefulness to it; one imagines the artist stepping away from his easel for a minute to conduct with his brush the mighty turmoil of the sea, with the wind doing its best to imitate *The Ride of the Valkyries.*

One thing Homer's paintings can't give you is the sound of the ocean, the thundering, the huge clatter of rocks as waves withdraw down the shingle, or the weak call of sea birds through a deafening wind. We leave that for the sound effects people who make the audiotapes for museum tours—and to poets, as when T. S. Eliot invokes "the sea howl/And the sea yelp . . . the distant rote in the granite teeth," or when Abbie Huston Evans speaks of "old ocean's hoarse and implicated roaring/ . . . its pent-in mouthless fury calling back/The wild first of creation."

Homer stilled the raging edge of the world; he made it hold still even when it lashed the land. He did not kill the landscape as lesser artists have done. He set it in paint forever, rendered it just right.

Success was not always his. Certain critics have knocked his handling of color values.[14] I can say myself that the spume in one of his studies of Cannon Rock comes off looking like a ball of yarn or some sea-born tumbleweed. Then I remember that it's a study, and that maybe the spray that day on Prout's Neck took that shape he created out of white chalk and set spinning above the dark granite that sends it all sliding back into the chasm of the sea.

PLATE 33 *Moonlight on the Water,* n.d.
Oil on canvas, 14³⁄₄ x 31¹⁄₂ in.
Los Angeles County Museum of Art
Paul Rodman Mabury Collection,
39.12.10

I pressed him [Homer] for a definition of what he considered the essential, the most important quality in painting, but he replied like one who had given little thought to distinctions or reasoning of this kind. I tried to reach his real judgment by asking if he did not think that beauty exists in nature actually and in fact had always existed, and must be discovered and revealed, simply and frankly. Quick as a flash he answered. "Yes, but the rare thing is to find a painter who knows a good thing when he sees it!" He added, "It is a gift to be able to see the beauties of nature."

Referring at another time to the power of seeing, he observed, "You must not paint everything you see. You must wait, and wait patiently until the exceptional, the wonderful effect or aspect comes. Then, if you have sense enough to see it—well," he quaintly added, "that is all there is to that."

—JOHN W. BEATTY,
"Recollections of Winslow Homer," 1923–1924

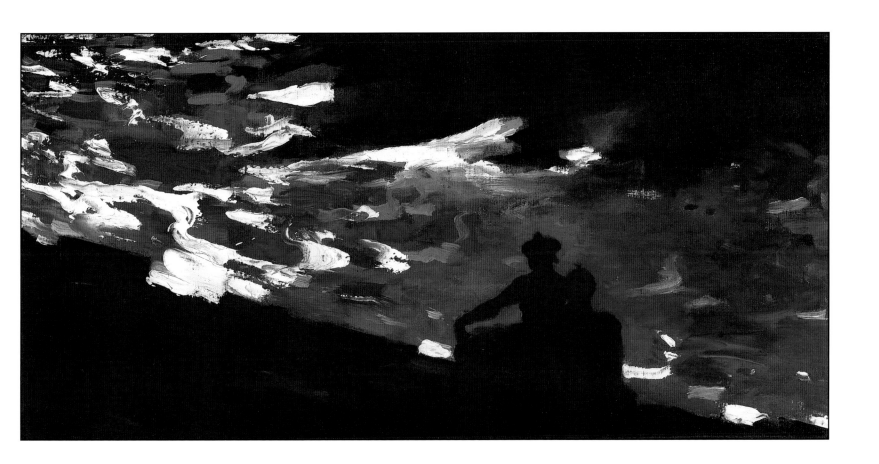

NOTES

1. Fairfield Porter found the name less poetic: ". . . Winslow Homer is like the name of a nineteenth-century New England farmer: the Christian name, which is personal to him, is a family name, unspecific and anemic. The last name suggests the Greek Revival. Such Yankee names disguise individuality under anonymity." *Art in Its Own Terms*, 1979.

2. "The extent of Homer's art education, as far as we know, was two years in a lithographic shop, some study at a Brooklyn drawing-school and the National Academy, and four or five lessons from a second-rate artist [Frederic Rondel] in the most elementary procedure of painting. . . . Certainly if any artist deserves to be called self-taught, it was he." Lloyd Goodrich, *Winslow Homer*, 1944.

3. Alexandra Murphy considers this image to be "the most dramatic and most powerfully conceived" illustration of Homer's career. *Winslow Homer in the Clark Collection*, 1986.

4. Taking a similar tack, Barbara Novak observes how Homer's "matter-of-fact realism" is "more in accord philosophically with Courbet than was Durand's ostensibly objective realism." *Nature and Culture: American Landscape and Painting 1825–1875*, 1980.

5. Curious to note that fifty years later, the same location would inspire Edward Hopper to take up watercolor.

6. Eakins once told a group of reporters that he considered Homer to be the best American painter of his time.

7. "*Diamond Shoal* . . . is a summation of the artist's best qualities . . . the work is a challenge to the technical abilities of future watercolor painters, all of whom owe him an acknowledgment for his influence on their development." Donelson Hoopes, *American Watercolor Painting*, 1977.

8. Philip Beam has noted that Homer "never painted a nude female figure" in his life. "His approach to the whole subject of sex was normal to his time and his background—respectful, chivalrous, even tender, but reserved and diffident." *Winslow Homer at Prout's Neck*, 1966.

Several contemporary writers have ventured to theorize what Homer's women might have looked like *sans vêtements*. In writing about Andrew Wyeth's Helga, as depicted in a piece called *Black Velvet*, John Updike remarks that this "American Venus . . . is what Winslow

Homer's maidens would have looked like beneath their clothes." *Just Looking,* 1989. Robert
Hughes, writing about one of Eric Fischl's nudes, *Girl with Doll,* notes how this child, "wiry,
squinting at the light and indefinably prole in her nakedness, . . . reminds you of one of
Winslow Homer's Maine girls, deprived of innocence and brought up to date." *Nothing If
Not Critical,* 1987.

In several pieces Homer depicted women wringing out the skirts of their cumbersome
bathing outfits. We're far from the tacky eroticism of wet T-shirts, yet the figures' clinging
clothes give them a sexual edge. A fine charcoal and white chalk study, *The Bathers,* 1882,
shows two women swinging each other by the hands in the calm sea in a kind of sensual
dance.

9. In her definitive study of Albert Pinkham Ryder, Elizabeth Broun traces the visionary
painter's descent into solitude. She notes that other artists "also distanced themselves from
Gilded Age materialism," including Homer, who "followed a similar progress into partial
seclusion but maintained a measured life that could not be called eccentric."

10. Besides Helen Cooper's superb book on Homer's watercolors, there are also several fine
studies on the subject, including "The Development of Winslow Homer's Water-Color
Technique" by Hereward Lester Cooke (*Art Quarterly,* Summer 1961) and "Observations
on the Watercolor Techniques of Homer and Sargent" by Judith C. Walsh (*American
Traditions in Watercolor,* 1982).

11. This point is most recently and perhaps most fully expressed in Bruce Robertson's
Reckoning with Winslow Homer: His Late Paintings and Their Influence, 1990.

12. One wonders that Homer didn't paint this place, except that marshes were not his cup
of tea as they were, say, Martin Johnson Heade's.

13. "During the early seventeenth century the promontory was known as Black Point, but
the first energetic family to settle there gave the name Prout's to the Neck in honor of their
principal forebear, Timothy Prout." Philip Beam, *Winslow Homer at Prout's Neck,* 1966.

14. In one of his letters, N. C. Wyeth makes derisive note of "the peeling criticism hurled
at [Homer's] 'uncouth color and clumsy handling, don't ye know.'"

COLOR PLATES